Bellies & Babies

The Business of Maternity and Newborn Photography

Bellies & Babies

The Business of Maternity and Newborn Photography

Sandy Puc'

WILEY

Bellies & Babies: The Art of Maternity & Newborn Photography

Published by
John Wiley & Sons, Inc.
10475 Crosspoint Blvd.
Indianapolis, IN 46256
www.wiley.com

Published simultaneously in Canada

ISBN: 978-1-118-40750-9

Manufactured in the United States of America

10 9 8 7 6 5 4 3 2 1

For general information on our other products and services or to obtain technical support, please contact our Customer Care Department within the U.S. at (877) 762-2974, outside the U.S. at (317) 572-3993 or fax (317) 572-4002.

Wiley publishes in a variety of print and electronic formats and by print-on-demand. Some material included with standard print versions of this book may not be included in e-books or in print-on-demand. If this book refers to media such as a CD or DVD that is not included in the version you purchased, you may download this material at http://booksupport.wiley.com. For more information about Wiley products, visit www.wiley.com.

Library of Congress CIP Data: 2012949010

Credits

Acquisitions Editor
Carol Kessel

Project Editor
Heather Wilcox

Technical Editor
Heather Harris

Copy Editor
Heather Wilcox

Editorial Director
Robyn Siesky

Business Manager
Amy Knies

Senior Marketing Manager
Sandy Smith

Vice President and Executive Group Publisher
Richard Swadley

Vice President and Executive Publisher
Barry Pruett

Graphics and Production Specialists
Dianne Russell, Octal Publishing, Inc.

Indexing
Margaret Troutman, Octal Publishing, Inc.

Interior Book Design
Dianne Russell, Octal Publishing, Inc.

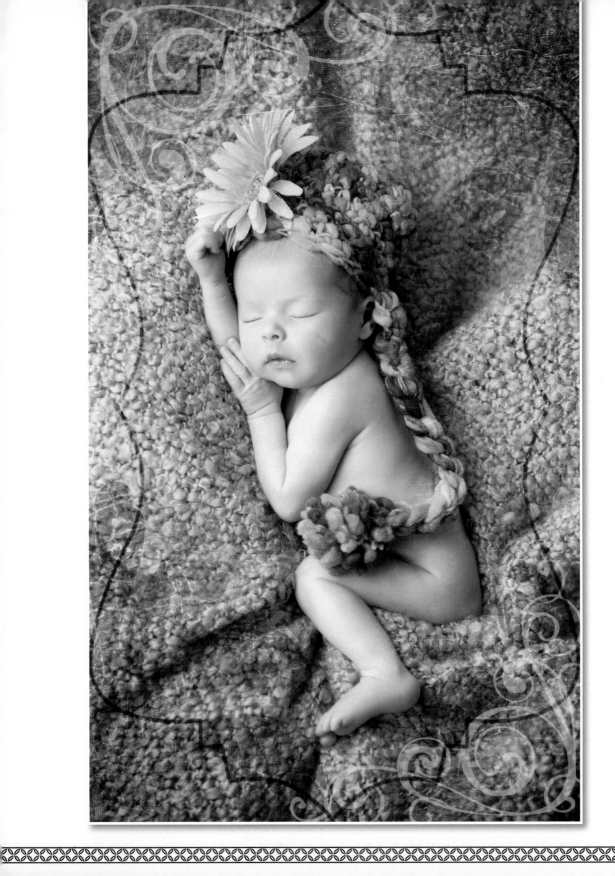

About the Author

Sandy Puc' is a nationally acclaimed photographer and businesswoman. She delights in sharing her knowledge and experience and spreading her passion for photography through her many speaking engagements, her international tours, and Sandy Puc' University. A 20-plus-year veteran of photography, Sandy served on the Board of Directors of the Professional Photographers of America for many years. She holds the prestigious titles of Print Master and Explorer of Light from Canon USA.

Sandy's commitment to community and giving back also inspired her to co-found the Now I Lay Me Down to Sleep Foundation in 2005. As the organization has grown over the years, seeing it touch so many lives has been one of the most meaningful aspects of her career. She received the Framed Network's 2012 Humanitarian of the Year award for her work with NILMDTS. L'Oréal Paris has also recognized her humanitarian work, naming Sandy a 2012 Woman of Worth.

Sandy resides in Littleton, Colorado, with her four wonderful children and her dog, Canon.

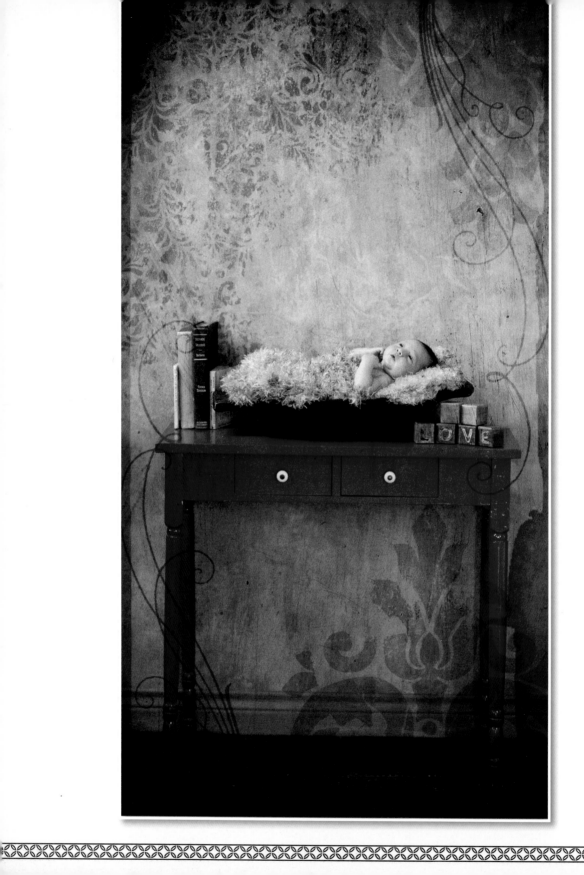

To my beautiful children, Katie, Alek, Nik, and Julz,
who are the inspiration for everything I do.

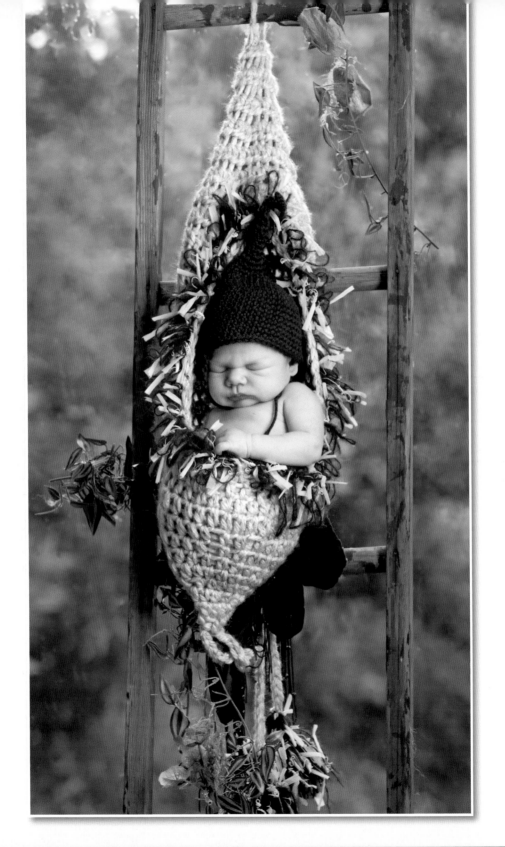

Acknowledgments

The journey of life is full of unexpected twists and turns. There are magnificent highs and painful lows as we forge our way down an uncertain path. Sometimes it feels that the only things we can really count on are the people we surround ourselves with every day. I have learned that possessions come and go, but the people who touch your life create an indelible mark on your heart. They ultimately become the glue that helps you keep your sanity when all feels lost.

During my journey, I have been blessed to have some remarkable people entering my world. Some have been a fixture from an early age. These people were the caretakers who forged the foundation of who I am. Others have become dear friends along the way as they helped me build my dream from the ground up. Some have entered and exited so quickly that they were but brief encounters or fading memories, but even those fleeting relationships left permanent marks.

I am blessed to have been raised by the most loving and kindhearted people on this Earth. My parents taught me so much about life and the gift of choice that to this day, I consider their opinions in everything I do. They taught me to love, and that ultimately it is not what we do or become but who we are and how we love that matters.

For the last 27 years, I have worked with tremendous thinkers who bring so much passion and energy to the table. I sit in awe as I have watched my company grow over the years, guided by individual minds with a common purpose. Their constant energy source has been the fuel that has propelled us through many adventures full of laughter and good memories. It would take an entire book to thank all the people who have helped build the company that we are today. But I want to thank a few special people who dedicated time to this book project to ensure that it was everything we hoped it would be.

To my dear soul sister, Erin: You are the most patient and forgiving person I know. After 17 years, I do not know how you put up with me, but I am quite sure we will be rocking in chairs far into the future. You are a gifted artist and my greatest friend. Who could have known that the day you randomly called me 17 years ago would have started an entire life adventure together?

Stephanie, you are an editor extraordinaire, and I appreciate that you can take my jumbled thoughts and put it all together so it makes sense. It is so nice to know someone who can cross the t's and dot the i's and get all of those thoughts on paper. Without your dedication, this book would still be just a good idea.

Finally, Cecelia, you are one of the smartest, most courageous women I know. I have been so blessed that in spite of me, you stuck around for the full ride. Your witty charm and constant humor keep everyone smiling. It is a blessing to know that if you are in charge, I have nothing to worry about.

There are so many others with whom I would love to share my thanks. However, there are not pages enough in the world to truly express my gratitude. So today, I focus on thanking those who helped with this book. Then tomorrow and beyond, I hope my actions will thank the others for their part in my life story.

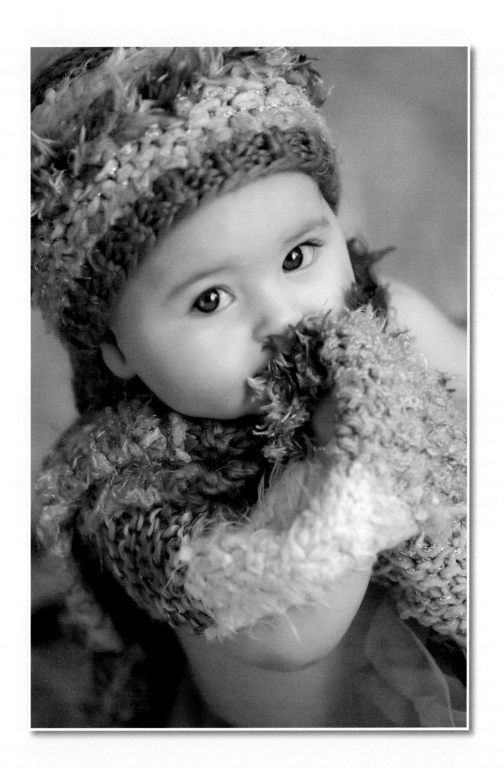

Contents

Introduction

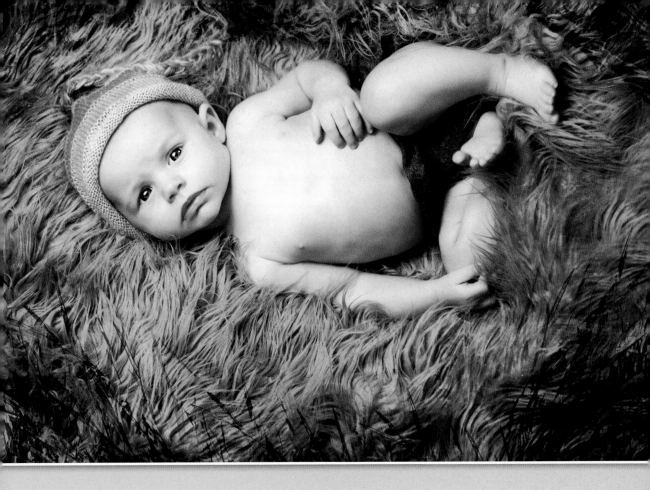

"*Dream no small dreams for they have
no power to move the hearts of men.*"

—*Goethe*

I remember the first time I picked up a "real" camera and held it in my hands. I was only 17 years old, but to this day I remember the overwhelming feeling of excitement as I looked through the lens and saw the world with new eyes. I can remember the weather, where I was standing, and how excited I was to play with this new tool. More than 20 years later, I still feel that emotion every time I pick up my camera and start my day.

Making my dream of building a successful portrait studio into a reality has been quite a process. There were many times when I wasn't sure whether my plans were going to work out. Through patience and a lot of hard work, I eventually was able to earn a living doing what I love. This dream and my love for photography stopped me from turning back and retreating in the face of difficulties. There was a significant learning curve, as I had no formal training and a young family along for the ride. The challenges were numerous, but the solutions came—lesson by lesson, one day at a time. I can't promise you that pursuing your own dream will be easy, but I can say that the goal of earning a good living as a full-time, working photographer is a real possibility for you, regardless of your circumstances as you read this book.

You may face similar challenges to the ones that I dealt with years ago. I know how it feels to be a young photographer whom no one takes seriously. In an industry that continues to grow rapidly, I understand the worry that you will not stand out in a field crowded with too many photographers.

As a baby and child photographer, I know how it feels to forge new territory, having entered the industry at a time when family and wedding photography were the main categories of professional work being done. Photographing babies and children exclusively was almost unheard of unless you were employed by a chain studio. As the mother of four beautiful children, I know how difficult it can be to balance a hectic family and work schedule. When I started working as a photographer full-time, I was also a foster mother to six teenage boys. Our household was bursting with activity at all hours. By the time I opened my first commercial space, I was pregnant with biological child number four. With our foster children, we officially had ten energetic kids in the house while I was trying to launch a demanding business. In addition, my husband retired after the birth of our last daughter to be a stay-at-home dad, leaving me fully responsible for our financial future. So it is with full confidence that I assure you that if *I* could find a way, with everything that I had going on, you can, too. It is possible for you today, with the resources that you have: time, ambition, and a dream.

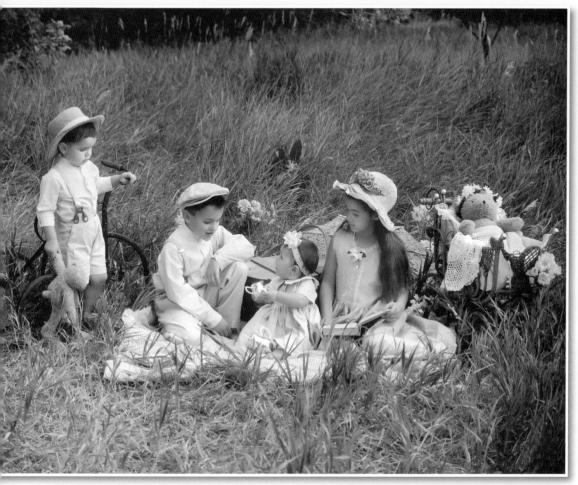

The Puc' children

"Cherish your visions and your dreams,
as they are the children of your soul; the
blueprints of your ultimate achievements."

—Napoleon Hill

Few of us allow ourselves to really believe in our dreams. However, you owe it to yourself to discover your dream and pursue it relentlessly, fully believing that you will realize that dream and achieve the success you desire. But how do you know when you've reached that pinnacle? Many people measure success by how much money they have in the bank, how many cars sit in their garage, or how many influential friends they have in their contact list. To me, success is summed up simply by how many times I get to experience my version of a perfect day. Take a moment to consider your perfect day. Grab a scrap of paper and a pen and jot down your entire vision, from the moment you wake up in the morning to the moment you go to bed at night. Now ask yourself: does your perfect day include a camera? Don't feel bad if the honest answer is "no." I don't know whether I can say now that my

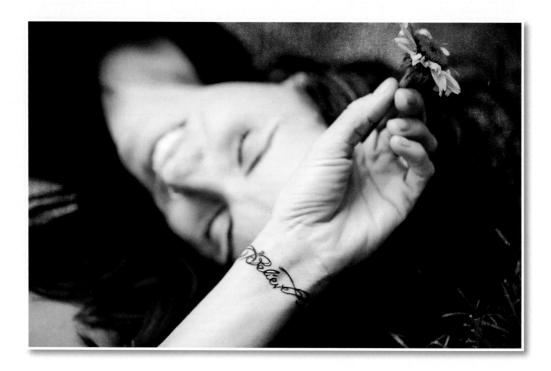

perfect day would include a camera, but when I was young, it definitely did. During that phase of my life, the best thing I could do would be to explore a new place, camera in hand, clicking away and feeling like a professional. Today, my perfect day involves spending time with my children while doing just about anything, although ideally a beach and a fruity drink are in the picture somewhere.

In reality, this question has no right or wrong answer—there is no one "perfect day." Instead, there are thousands and millions of them, each one unique to its dreamer. My perfect day might be a disaster for someone else. Another person's perfect day might be miserable for me. The truth of the matter is that only when you take time to ponder what "success" means to you can you find your perfect day. Once you know that answer, you can make the necessary adjustments in your life that will bring you one step closer to achieving your own version of perfection.

A wise person once said, "What you do today is important, because you are exchanging a day of your life for it." This phenomenal concept has become crucial in my personal philosophy. As we work and struggle through our days, putting off our dreams of happiness and contentment for "tomorrow," we are exchanging one day at a time for the promise of a tomorrow that is not guaranteed to even exist. When I first read that quotation, I decided to figure out about how many days I really had left on this earth. According to my calculations at the time, if I lived to see my senior years, I would have approximately 13,000 days left. I remember looking at that number and feeling numb for a few moments. Only 13,000 days? That did not seem nearly enough to do all the things I had dreamed about, especially when you consider how few "perfect days" we really get in our lifetimes. We work very hard for the few moments of peace and enjoyment that we do get. When I ask my students how many perfect days they get per year, a typical answer is four to eight. When you consider this number, it doesn't seem nearly adequate. Recognizing that most of us truly enjoy so few days each year is a strong motivation to make every day count.

Although this book is intended to help you find your dream, understand that achieving it will take hard work and determination. Most people think that money will get them what they want, but in the end, only time gives us the memories that we will cherish for the rest of our lives. Although this book is full of ideas to help you make a living at your dream, always remember that my ultimate goal is to help you spend time with the people you love. Your goal is to earn enough money to then have the *time* you need—the money itself is not the thing you need.

Maintaining this perspective helps me discover and pursue my dreams every day, and I hope it will do the same for you. I have found fulfillment in my life by continuing to pursue my perfect day. Knowing that time is a gift that you must earn will help you set your priorities so that you can reach your goals and realize your full potential. On your journey as a photographer, I promise that having a good plan can truly be the wind in your sails, taking you wherever you want to go. I'm honored to share the lessons, methods, and techniques that I have acquired and applied over the years to build the career and the studio that I have today. If you modify them to work for you, they can help you realize your dream and give you many perfect days.

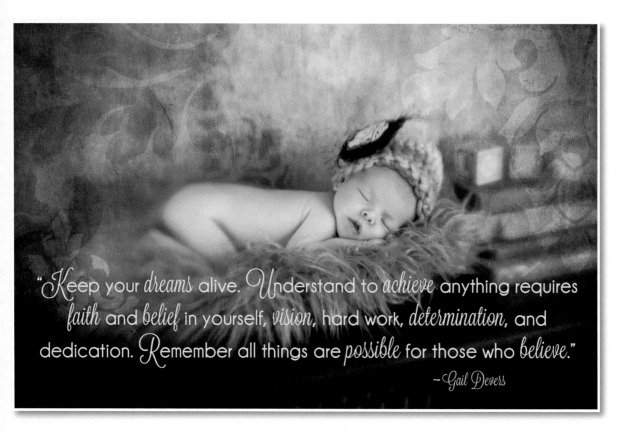

"Keep your *dreams* alive. Understand to *achieve* anything requires *faith* and *belief* in yourself, *vision*, hard work, *determination*, and dedication. Remember all things are *possible* for those who *believe*."

~Gail Devers

"*Life begins at the end of your comfort zone.*"

—*Neale Donald Walsch*

Chapter One

The Baby Plan

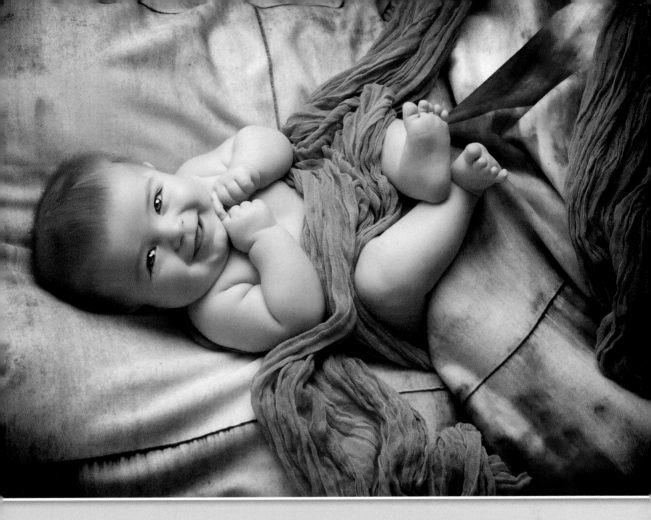

Whether you want to run a bustling commercial studio or a high-end boutique, a well-organized and carefully executed baby program is an excellent starting point. Not only is it a wonderfully profitable element to any portrait business, but a baby plan can lead to life-long client relationships with the families whom you meet during this monumental phase of life. In the last few years, many of the high school seniors whom I photographed were some of my original baby plan clients. Most of the family portrait sessions that I do now—often the highest grossing sessions that I see—are for families whom I met originally through a baby program. As my portrait business has grown over the years, I have learned the hard way that a baby program is literally its lifeblood.

Many years ago, I attended a business seminar. At the time, I thought I had a successful business built around my baby plan—I had tons of sessions, and my clients were happy. But at this seminar, an advisor evaluated my company and made the shocking suggestion that I eliminate my baby plan. We calculated at that point that I was doing three times more baby sessions than anything else, yet they yielded the lowest sales average per session. Logic told me that getting rid of the baby plan would leave me with more time to book the sessions that had higher sales. So with this knowledge, I went home and started the process of eliminating the baby plan. For a few years, this adjusted focus worked: because I had more time with my higher-paying clients, I was working less and making more. It wasn't until years later, in the middle of a recession, that I realized the error in that decision.

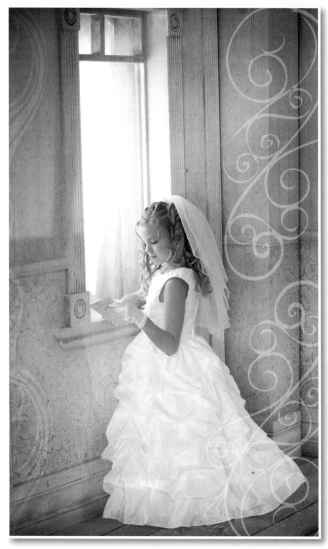

After years of success, I found myself struggling with bills and overhead costs, and I feared that I would soon be out of business. I had lost faith in myself, and even my bookkeeper left me. One day while I was in the depths of depression and fear, a client showed up for her session. I remember walking into the room and feeling so overwhelmed by my situation that I was nearly crying and did not know where I would find the strength to do my job. I walked into the studio and saw a beautiful, perfectly dressed little girl, all ready for her Holy Communion session. She was stunning, standing there all in white with the brightest smile and the face of an angel. Her beauty excited me, thinking about the potential art that I could create. I felt a spark that had been absent for a long time, and after a wonderful hour of shooting and forgetting my troubles, I turned to the mother and said, "Thank you so much for allowing me to photograph your daughter."

She looked at me and said something that changed my entire business: "Sandy, no, thank *you*. You are the only professional who has ever photographed my daughter."

I stood there for a moment as a lightbulb went on. I remembered that the very first time I had photographed this little girl was when she was an infant—she was one of my original baby plan clients. I suddenly realized that when I eliminated the baby plan, I eliminated a real connection I had with my clients. Although my baby plan clients were not big spenders, they were loyal and even in hard economic times would not miss a session with "their" photographer.

In that moment, I realized the continued value that a baby plan could offer my business. The lower baby session sales were just one piece of a larger picture that I had neglected to consider fully. I don't know how much that particular client had spent on her child's baby plan, but it was clear that over the years, she had become a loyal client following that initial experience. As babies grow, a client's financial status often grows as well. Those new, young parents who spend a few hundred dollars on photos of their newborns later spend many hundreds or even thousands on family portraits because they have become more established and financially sound. My very best spenders were all originally baby plan clients. When I eliminated that plan, I also eliminated the opportunity to create life-long relationships with new clients.

From that point, reestablishing a baby plan became a big priority for me and for my studio. I walked out of that session knowing what I needed to do. I wasted no time creating a fresh baby plan and marketing it aggressively, but this time I carefully planned my pricing, product lines, and added value incentives so that I could ensure not only loyalty but better sales averages. Sure enough, this strategy made an immense difference, reviving the business and providing ongoing clients and referrals whom I have the honor of photographing to this day.

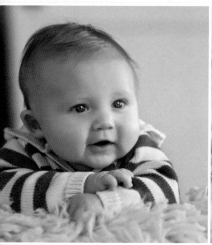
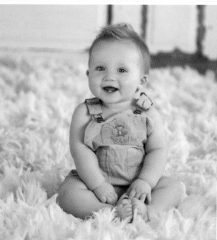
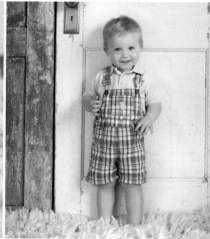

What Is a Baby Plan?

A baby plan means different things to different photographers, but I will share my tried-and-true baby plan with you with the hope that it will guide you as you develop your own business. A good baby plan will carry a client's child from birth through the first birthday. Typically, it includes a newborn session with the parents (I call it a Madonna session), followed by three-, six-, and twelve-month sessions. Baby plan clients purchase the entire program upfront, paying for all the session fees as well as a final product that features a portrait from each session. These gorgeous series products do not disappoint, but, as you can imagine, they are also not the only products that baby clients purchase throughout the year.

At Sandy Puc' Photography, I offer two options in my Bebé Program. The Associate Series, also known as the Petite Bebé, is photographed by an associate photographer and includes three-, six-, and twelve-month sessions. This program has a low entry fee (currently $199) and includes a three-view folio upon completion of the program. This is my studio's loss leader. The discount on this first option for the program is slightly more generous than the second, but if the associate does his or her job well, the client will invest even more than the initial fee.

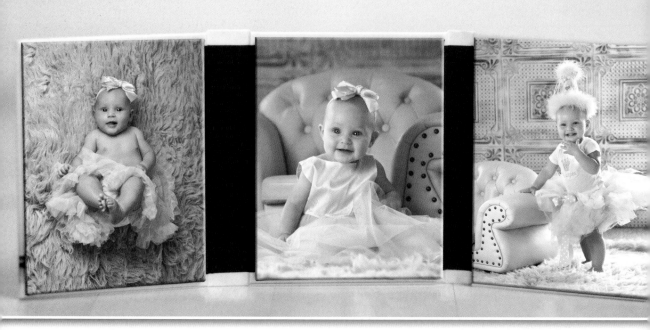

Petite Bebé series

The second baby plan option I offer is the Master Series, known as the Grand Bebé. This series includes a bonus Madonna session (usually at the six-week mark, if not sooner) as well as the three-, six-, and twelve-month sessions and a framed three-image art piece. The fee for this series is currently $299, but the price of the frame adds value. Typically I shoot the Master Series, so a client who wants to work with me personally will need to pay more upfront for the program but will use the same slightly discounted price list as with the Petite Bebé for the ordering process. Once the session has occurred, the parents come in for a sales consultation. The images have been edited to the best 30 to 40 selections and are presented in a slideshow format set to music as well as shown individually to help the parents cull down to the favorites. They then order from the discounted baby plan pricelist.

They also choose their favorite image from that session to be used in the final product they will take home when their baby turns one. The client must complete the entire series to take home the first-year art piece. This strategy ensures that clients invest in portraits at each session, as they typically do not want to wait for an entire year to show off their newest family member.

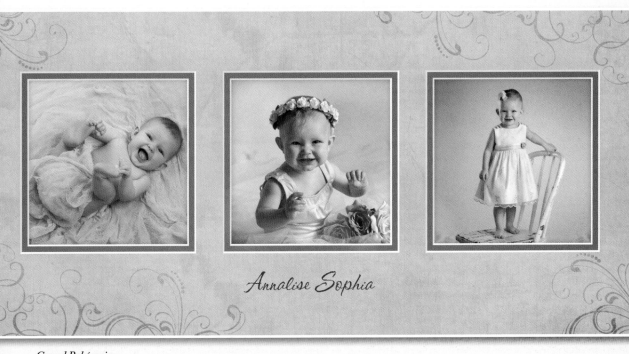

Annalise Sophia

Grand Bebé series

When it comes to pricing and packages, the formula that helps ensure success is that clients must order from each session as they complete them; they cannot book another session until the previous session's order has been placed. They also cannot carry over packages and must treat each order as a single session.

I refer to the selected favorite Bebé images from session to session so that I can be sure to match color tones in at least one of my sets to create consistency for the final art piece. I don't recommend that parents stick to one background, but I am looking for some continuity in the final series. I encourage them to select the image that tugs their heartstrings, but often Mom wants to go with an all-black, pink, or blue theme, so I make sure that she has that option.

For clients to receive the final end-of-year product, they must complete each session. I do not offer refunds for canceled baby plans. (Make sure that such a stipulation is featured as a disclaimer on your baby plan marketing or price list.) However, I love my clients and will work with families who may be relocating to a new state or dealing with other unexpected situations of that nature.

I provide a brief overview of each session here, with more detailed information to come. The important thing to remember is that the purpose of each session is to capture the milestones. Document each new stage throughout the first year so that the final series really showcases the baby's development. I discuss shooting each session with specific products in mind so that it will be hard for clients to resist placing orders when they see how adorable each image looks. By following these guidelines, you can be sure to hit your sales goals with each and every baby session in the plan.

Newborn

This first session is hands-down the most important and highest-yielding session of the entire baby program. Sales averages here are typically three times higher than in the other baby sessions.

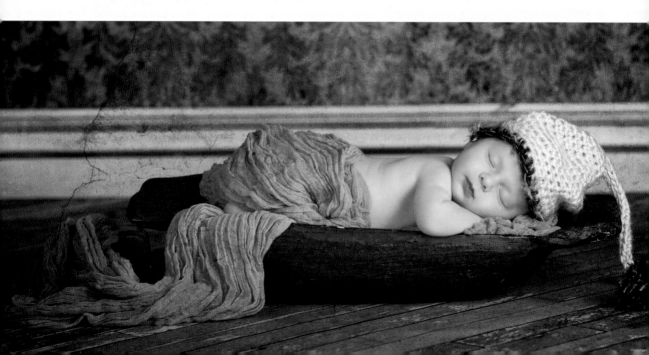

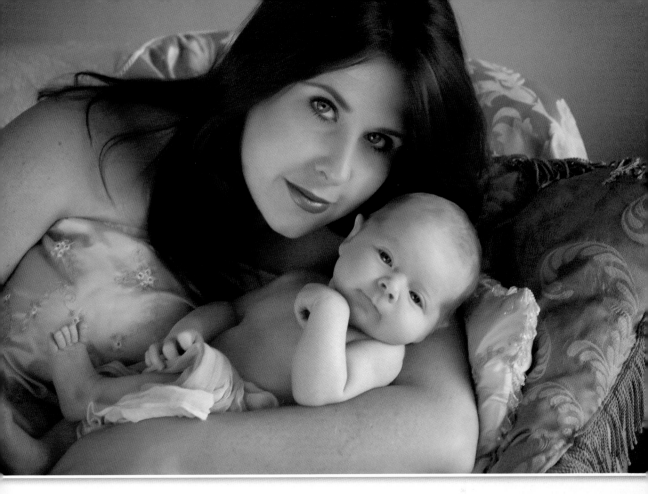

Without fail, the younger the baby, the higher the sales total. Keep this information in mind as you schedule the Madonna (mother and child) session with your clients. Also note that I try to book the first session before the baby is born, because a new mother will not necessarily remember to do so after the birth. Try to be flexible if the baby arrives sooner or later than expected to ensure that the infant is no more than a few weeks old at most. Ideally, a five-day-old baby is perfect for these sessions. I request that a mom-to-be book her session five days after her due date so that if she delivers early, the baby is still usually fewer than ten days old.

A baby younger than ten days is completely helpless and very delicate at this phase, which contributes to the beauty of these sessions. Later I discuss poses for this session and safety considerations when working with such a young baby.

As far as products go, most Madonna session clients will make several important purchases. Birth announcements are a big one—you can offer a wide variety of styles by using product templates from such sites as my design store, Ukandu.com. Display them in a product binder and show them to your clients before their sessions during your initial consultation. Present these samples again during the sales meeting. You can expect most parents to buy anywhere from 50 to 100 birth announcements.

September
25, 2010

10:34 a.m.

7 lbs
12 oz
18 in

proud parents
Mike &
Josie
Campbell

Christopher
Michael

SANDY PUC
photography

303.730.8638 | sandypucphotography.com

Framed wall art is another popular choice for the Madonna session, as it features quite a few wonderful poses with both parents. The most popular and profitable series features tight shots of the baby's hands, feet, and face. This collage always sells, so these images are a must to shoot.

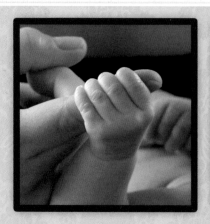

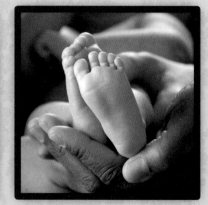

Three-Month Session

The three-month session might be the first session if the clients are purchasing an Associate Series baby plan. With a Master Series, it is the second session. In either case, the baby is changing and growing quite a bit already. At this age, most babies can lift their heads, follow regular schedules, and know their parents well. The milestone shot for this age is a classic image of the baby lying on his tummy and lifting his head, but offering a variety of hats and props gives your clients more options to buy. Using a ladder to shoot from a high angle (for you, not the baby!) can also add visual interest, but it must be done safely (more on this later). For Associate Series clients, this session is an ideal time to order baby announcements as well.

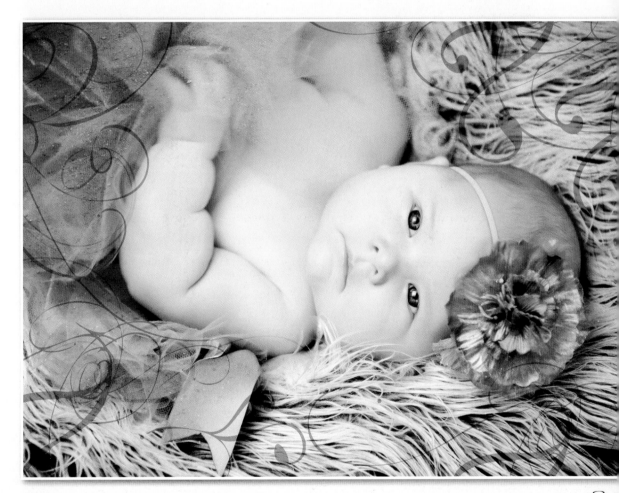

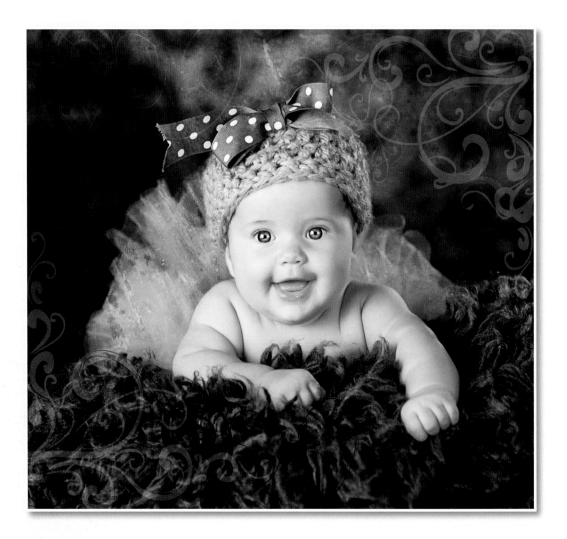

Six-Month Session

This phase brings plenty of cute moments with a chubbier and more energetic baby. Usually babies can sit up on their own for this session, but be sure to always keep a parent close by—babies can roll forward or backward suddenly, and when that happens, the session can be all but ruined. Make sure that parents are alert and engaged in the process at all times. Again, shooting from a ladder allows you to capture a variety of dramatic looks.

Shots of chubby baby bums are very popular for this session. Be sure to also capture tight shots of eyelashes, cheeks, fingers, dimples, and other unique features. Framed series are a popular product choice for this session, as they capture the movement and personality that is developing at this age. Showing a series that includes images of the baby playing with blocks, flowers, or a book also helps sell storyboards, collages, and other art product options.

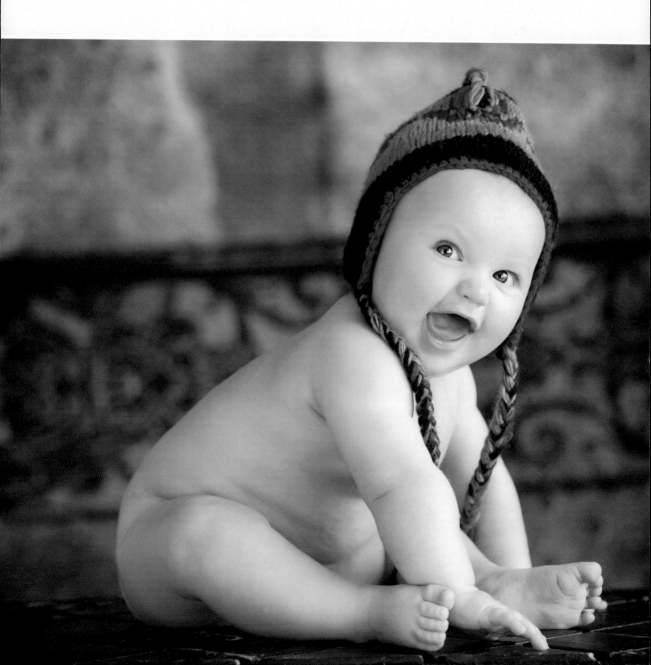

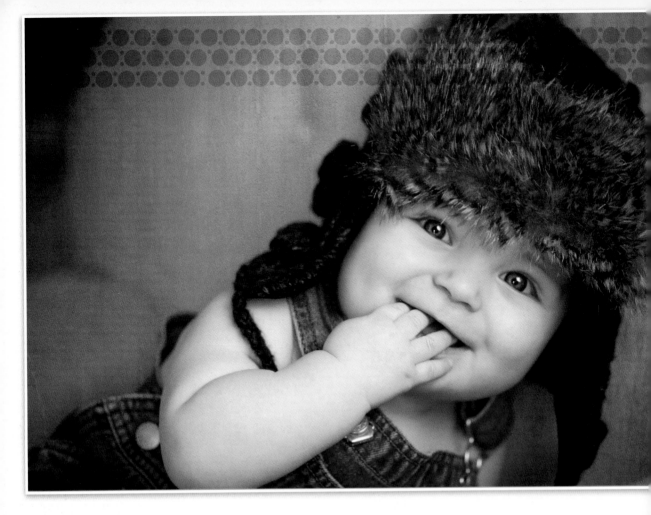

Twelve-Month Session

The twelve-month session is special—it is the final one for the baby program and marks the transition from baby to toddler for your clients. It also typically yields the second-highest sales average. Most babies are standing (if not walking) on their own by this time. Your subjects will have become very attached to their parents, so be prepared for a little extra clinginess. One of the most adorable things about this age is how much fun it is to dress them up. When a little boy wears a tiny suit or a girl wears a pretty dress, the baby's eyes light up. They are just like us—when they are dressed up they feel special. Most babies at this age can understand you when you talk to them, so offer simple directions, such as "Look at Mommy!" or "Get the bear!" and they will sometimes go along with them. Keep in mind that if you speak clearly and don't use a baby voice, they can understand you—they just may not choose to listen.

This twelve-month session is busy. One-year-olds are active, so be ready to capture tons of movement: running, walking, jumping, and laughing. I also tell clients that they can bring in a birthday cake for the last few shots of the twelve-month session. The messy birthday cake series is a favorite and usually results in a fun storyboard. Custom first-birthday announcements and thank-you cards are also great products to sell after this final baby program session. Because it is the last session in the baby plan, clients also make their final choice of an image to include in their baby folio or framed art piece.

Exceeding Expectations

With the baby program, your goal should be to exceed your clients' expectations at every step. From your customer service to the session experience to an outstanding product and a welcoming and comfortable sales process, they should feel like VIPs the entire way. Even if clients' sales numbers aren't as high as you had hoped after the first session, remember that these clients are potential life-long patrons. Once you have gained their trust, their return business is practically guaranteed over the years. They may not return every year, or even

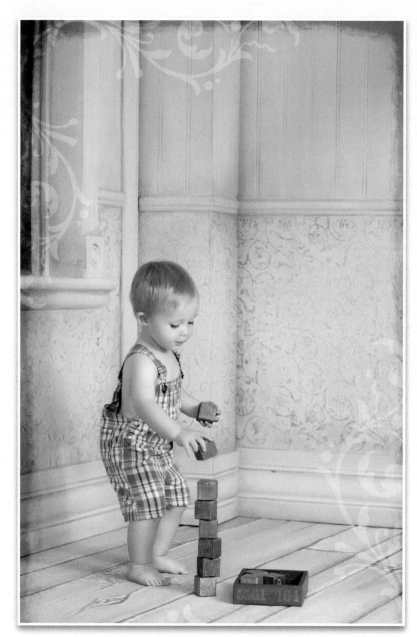

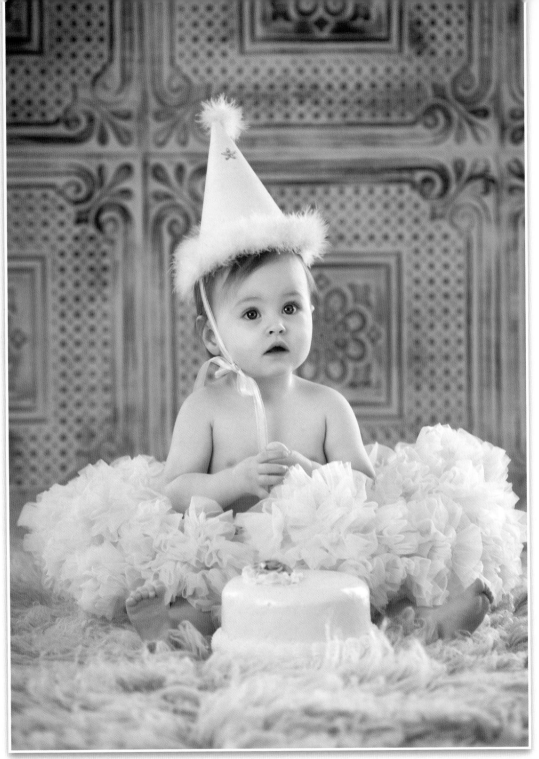

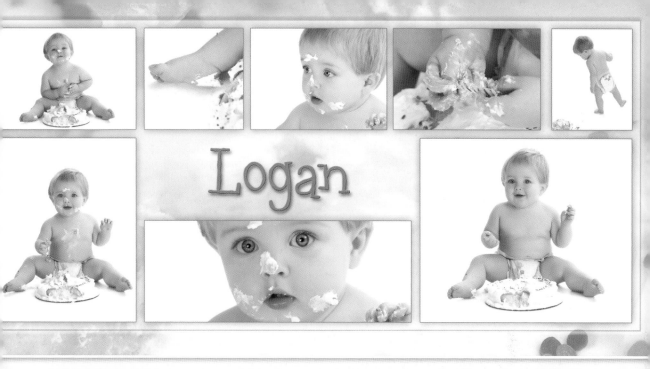

every other year, but if you've done your job right, they *will* be back for children, family, and senior portraits. Not every baby plan client will end up being the loyal, high-spender that you dream of, but treat them all as if they are, because you don't want to hurt your chances of retaining their business or earning their recommendations to a client who just might be that dream spender. More importantly, no matter what size studio you are working toward or the photography techniques you offer, you want your name to be synonymous with style, personalized service, and exceptional quality. Every aspect of your business should reflect these traits.

"Ideals are like stars; you will not
succeed in touching them with your hands.
But like the seafaring man on the desert
of waters, you choose them as your
guides, and following them you will
reach your destiny."

—*Carl Schurz*

Chapter Two

Creating a Marketing Plan

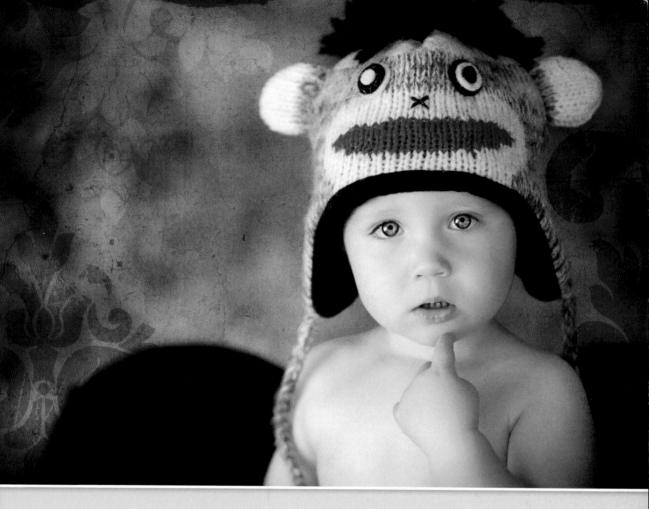

Now that you understand the value of a good baby plan, you're ready to start marketing one in your area. Many photographers have tried numerous different techniques with varied levels of success. In this chapter, I discuss the methods I use to market my baby plan along with useful tips and tricks to customize this basic plan for businesses of any size.

Know Your Market

*"When you are average, you're just as
close to the bottom as you are to the top."*

—*Unknown*

Most new mothers today differ from the young mothers of decades past. They are looking for variety, freedom, and style. Mothers today want to be unique and stand out from their friends. Most people don't know this, but women between the ages of 30 and 45 represent *the largest spending group in the world*, although they are not necessarily the highest income-earners. I know this is the target market for the baby plan, as I typically work with women within this age bracket. As a professional photographer, you have to discover your ideal client within that demographic, be it the coupon-clipping bargain hunter or the wealthy socialite.

With marketing, the playing field is never level. Be prepared for some competition. Most new business owners don't really care who their clients are when they first open their doors—they just want paying customers. However, over time you will begin narrowing down your preferred clients with pricing and specialization to identify the market that you truly want to work with. Correctly branding your baby program is another great way to position your studio to attract your most desired clients.

Continual Marketing

At Sandy Puc' Photography, the baby plan has a shabby chic style. Although it has evolved over time, light tones and an elegant font are the design approach that has been most successful in my studio. That said, there are many approaches to baby program branding, so you must evaluate your style and clientele to find the look that will sell best. These designs should be incorporated into such pieces as an informational brochure, price list, business cards, appointment cards, and even your website. Developing a signature look for your "brand" is known as continual marketing—you keep putting it out there day after day, month after month, and year after year. For this reason, it's critical that you choose a design that you can commit to, because the longer you use it, the better your brand recognition will be.

Baby plan postcard

Baby plan business card

7201 S. Broadway
Littleton, CO 80122
303.730.8638
www.sandypucphotography.com

Sandy Puc' Photography presents

The *Bébé* Collection

SANDY PUC
photography

SANDY PUC
photography

7291 S. Broadway
Littleton, CO 80122
303.730.8638
www.sandypucphotoscrapper.com

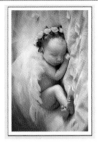

Call 303.730.8638
now to schedule your
appointment.

What is the Bébé Collection?

Welcoming a new baby into the family is an exciting and emotional time. A baby's first year is full of rapid changes that mark the milestones in her/his growth. We created The Bébé Collection to capture these moments in time and provide heirloom treasures that will be a joy to view for many years to come.

From the first time she lifts her head or sits up alone to those first real steps, we have designed the perfect collection of sessions and images that will capture these remarkable moments.

The Beginning Newborn to 3 months

What a joyous time to capture the essence of your new little one. Tiny fingers, toes, and all of the details that will be treasures for years to come. Your baby will be bare or in a diaper cover. This is also a great time to create wonderful relationship portraits with Mom and Dad as well.

The Moment 6 months

At six months your baby should be sitting up independently. These moments are full of giggles and smiles. Clothing should be kept simple. Diaper covers, bloomers, overalls, and tiny tulle skirts are perfect for your baby's session.

The Freedom 1 year to 13 months

The best time to capture this session is when your baby is standing alone or taking a few steps. Now the fun really begins! Clothing can be simple or your baby can be all dressed up. Bring a few outfits, and we can choose the ones that will work best for your series. Don't forget to ask about our birthday cake series.

The Bébé Collection

The Bébé Collection includes:
• Three one-hour portrait sessions at
 3 months, 6 months and 1 year
• One art portrait from each session
• Special Bébé package pricing
• 10% off all birth announcements
• 10% off all portrait jewelry and handbags

Bébé Grande $299 : A $950 value:
Includes three 5x5's in a gallery frame

Bébé Petite $199 : A $525 value:
Include three 4x5's in a leather display folio

Capture the miracle of life in a timeless expression of love with pregnancy portraits. Create heirloom portraits to remember this time forever. Best times for this session are between the seventh to eigth month of pregnancy.

Associate Maternity session $75

Save $30 when purchased with any Bébé Collection package.

Baby plan mailer

Another form of continual marketing is a good newsletter. You can design a digital or printed version, and a quarterly edition is usually a nice frequency. I provide both a printed and digital version of my newsletter. The digital version goes out in an e-blast, or mass e-mail, and another copy resides on my website so that anyone who is visiting my site for the first time can get a real sense of the personality of my studio. I also send out a printed version, because moms still tell me that their best reminder of what is happening is still the refrigerator door! Include a personal letter to your clients. The more real you can become to them, the more loyal they will be. So include stories about your family, travel, and other fun updates. You might be surprised to learn how much more effective this type of marketing can be compared to price specials and other "buy-now" strategies. Photography is highly personal, and clients love knowing the artist they work with. Between the quarterly newsletters, sending a monthly e-blast is another good way to stay in touch with your current clients.

Continual marketing isn't complete without a good referral program, which encourages clients to refer their friends and family to you. An easy way to manage this is to offer a complimentary portrait or a credit toward a session to every client whose referral results in a booked session. Include a few disclaimers on these types of offers, such as no cash value, new sessions only, expires one year from postmark date, and minimum purchase applies. With these precautions in place, it is perfectly fine to offer an unlimited number of referral rewards to your clients to keep those referrals coming. Although my referral forms include a one-year expiration date, I understand that some clients only come every few years, so I bend the rules a little as needed.

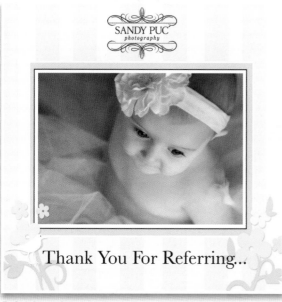

Baby plan referral card

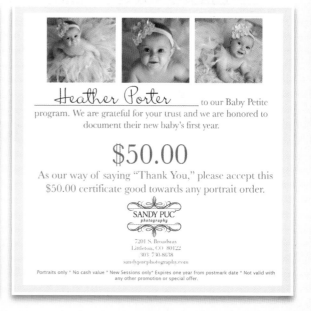

Business referral wallet-size prints are another way to market your business through current clients. Choose your favorite image from each client's session and add your studio logo, name, and contact information. Include a half dozen or so wallet-size images in the order as a bonus gift, and your clients will happily give them to family and friends (and don't forget to keep one for yourself, because laminated wallets on a key ring are wonderful samples of your work!). These wallets give your client several chances to brag about and share your work—and they will!

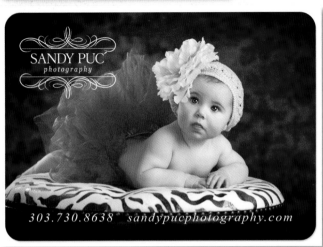

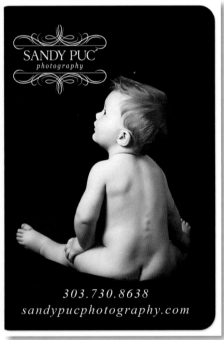

Referral wallet samples

You can even create a specialized baby plan referral program, which I have had quite a bit of success with at my studio: offer your current clients the opportunity to give their expecting friends a gift certificate for a baby program. Although I sell this as a discounted loss leader, the retail price of the three sessions and folio is well over $600, so when a client gives this to a friend, it has high perceived value. However the actual cost is reasonably low, and this is a sure way to get qualified clients. Once the gift recipient books a session, the person who referred them gets a $50 credit on his or her account. This is a win/win: I get new clients while providing an incentive for clients to talk about my studio as well. Trust me, every new mother who walks into your studio knows someone else who has a baby or is about to. So look at your current clients as your best marketing tool. Find ways to get them excited to talk about you and reward them generously when they do.

Specials and Temporary Marketing

Beyond continual marketing, several special marketing tactics can help you get new clients in the door. Friends and family are a great place to start, of course. Next, you can try a model search.

A model search basically offers new and existing clients a complimentary session with a credit toward a purchase. A word of warning: *never* give a free product (such as an 8×10) with a model search program! If you offer a free session *and* an 8×10, there is a great chance that the client will only take the free product and not invest. Using a portrait credit instead—particularly one with a relatively low value—encourages the client to spend more. Keep it relative to your prices. In my studio, I offer a $100 credit, but my 8×10s start at $150. If your 8×10 is $40, *don't* offer a $100 credit. My rule is the credit should be just under the price of your 5×7 to start. Then modify as you find what works best for you.

A model search works well during the slow season. This is typically between January and April, but that can change depending on where you live. It is okay to offer this campaign to your current clients the first time you try it, but after that, find ways to use it for bringing new clients in the door; otherwise, your regular clients may start to anticipate the campaign and abuse the system a bit.

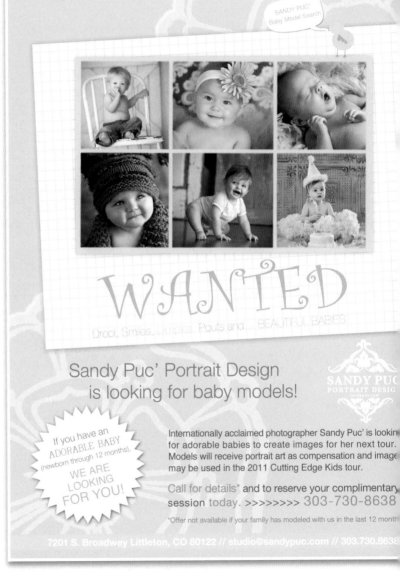

Working with a children's store, putting up local displays, and teaching a basic photography workshop at moms' groups are all great ways to get the word out. I have even left flyers in public restrooms in nice shopping malls before. Hey, I know people go there, and it is worth a few extra flyers to try it out. No idea is too silly when it comes to exposure.

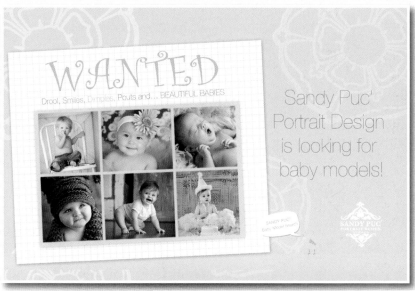

Show Your Work Everywhere

Community displays are another great temporary marketing effort. Although some are very short-term, such as tabletop displays with fishbowl drawings at local events, small businesses, and seasonal locations, other displays can be more permanent, lasting up to two or three years. Doctors' offices, malls, and hospitals are some excellent locations for semipermanent displays.

The first hospital display that I did was the result of a doctor and nurse couple whom I had photographed. They approached me with the project, offering a $10,000 budget and a three-month deadline. The portraits were to be 30 inches or larger, using current clients with a release for the hospital to own the rights. As you can imagine, I was taken off guard by this proposition. Until that point, all displays I had ever created were donations, so to be offered payment was exciting, to say the least. After regaining my composure, I was eager to accept it. Since that time, I have designed many other hospital displays, none of which I have been offered money to create, but each one has provided exposure that was well worth my investment.

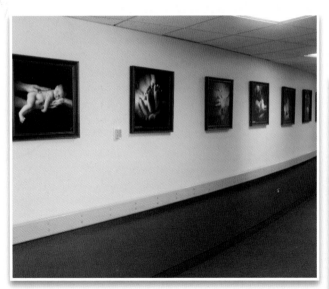

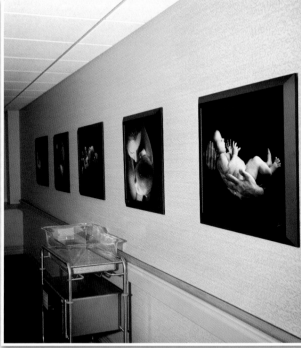

Through this process, I have developed some great guidelines:

◈ Allow six to nine months to create a display.

◈ Approach the hospital with an offer to make a substantial donation of art and ask to be connected to the person who handles such donations, typically the facilities director.

◈ Create a contract with the hospital that lays out the terms of the display, including sizes and location of the portraits, and guarantees it will keep it up for a set amount of time.

◈ When establishing your budget for each display, remember that, for maximum impact, each image should be 30 inches or larger, so plan accordingly.

◈ Choose hospital staff and families to be models for the images, each receiving a complimentary session and credit toward a purchase.

◈ Sign every portrait and include a small plaque with the studio name on every third or fourth one.

These guidelines are almost exactly the same when you're creating a doctor's office display, but in that case, the number of portraits is much lower, and you can be more generous with the credits provided, because it is a much smaller office setting. In any case, don't discount the emotional power of these locations—particularly hospitals. Many women pace the labor and delivery hallways for hours while they are in the early stages of labor. As they gaze at your work, it's impossible for them not to attach the expectation of their new babies to the magic of your larger-than-life portrait displays. One of my first hospital-display clients came to me with a tiny newborn baby in tow. When asked how she heard of us, she said, "You know, this was my first baby, and because it was such a difficult delivery, it might be my last. The labor was very long and painful, and as I was walking past your displays in the hospital, I turned to my husband and told him, 'If I ever get through this alive, you're buying me one of those!'"

We had a good laugh over it, but the story is not uncommon. Birth is one of the most vulnerable moments a new mother faces, and the tranquil portraits of a new baby can really encourage women through their labor and give them something to look forward to afterward. Hospital displays have proven to be very effective for us. In some cases, the phone would be ringing almost overnight.

I try to maintain a generous attitude toward hospitals rather than a what's-in-it-for-me stance, which often makes their raves better and leads them to ask for a business card or brochure of some sort. If you offer your marketing pieces from the get-go, you may be turned down. However, after a few days or weeks, hospital staff will likely ask you for something to give out so they don't have to look up your number for interested patients. Once they ask, you can provide them with a gift certificate featuring the hospital's name and providing patients with a complimentary session. This makes the hospital look generous to their patients and encourages them to come through your door at this pivotal time in their lives.

Hospitals and doctors' offices aren't the only place where a semipermanent display can be highly effective. Community displays, such as boutiques, malls, or new home shows, can be a wonderful source for walk-through traffic. When I teach this type of networking at my workshops, everyone always wants to know whom to call first. A hospital or a mall is large and impersonal and almost always has some type of facilities director or coordinator on staff who is in charge of displays. Boutiques are more intimate, and often the person working behind the counter is also the owner. For these smaller venues, you need to browse the store and maybe even buy something if you truly love it. Establish a relationship with the owner by getting to know the owner's business. In Colorado, we have the yearly Parade of Homes, a home showcase of absolute dream houses. To have my work displayed in these homes, I work with area designers, architects, and homebuilders who are participating, and many times that relationship continues after the show, with these contacts giving gift certificates for my studio's services to their clients to thank them for their business.

My first mall display turned out to be a lesson in networking. By being honest about my budget, passionate about my work, and generous with my delicious cookie-giving tradition, I was able to establish a very high-grossing display for years at an affluent mall in my area. So don't get discouraged—be warm, genuine, and proactive. Where there's a will, there's a way! Most display arrangements will be made through relationships that you generate and foster between yourself and local businesses frequented by your target market. And even if you don't get a display up, don't neglect those relationships, as they can also lead to potential referrals over time. I've had business owners who initially turned me down end up becoming loyal clients and eventually requesting displays.

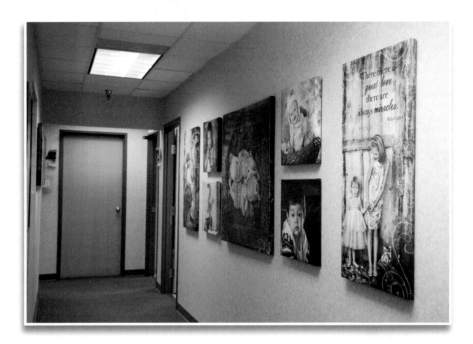

Creating a Marketing Calendar

Now that you have a wealth of marketing campaigns and initiatives to implement in your community, both ongoing and temporary, it's important to organize these efforts in a marketing calendar.

The marketing progression includes four stages, and you need to allow about a month for each stage. So work backward from the date you want to hold any given session, allowing yourself about a month to complete each phase. This will help you keep track of everything that is going on and stay organized. You can incorporate your social networking into your marketing calendar as well, since it will directly correlate to the sessions you are planning at any given time.

SPU — SANDYPUCUNIVERSITY.COM — February 2013

Legend: Design Stage · Proof/Press Stage · Mailing Stage · Social Media · SPTV

Sunday	Monday	Tuesday	Wednesday	Thursday	Friday	Saturday
					1 Birthday Card Engagement	2
3	4 Winter Wonderland Family Portraits	5 Homecoming Campaign	6 Ballet Babies LE SPTV (12:00 EST) Week 1	7 Precious Pets	8 First Communion	9
10	11 Spring Newsletter	12 Birthday Card	13 Summer Newsletter SPTV (12:00 EST) Week 2	14 Model Search	15 Pet Timelines and Announcements	16
17	18 Frosty LE	19 Tea Time LE Birthday Card	20 Take Two Campaign SPTV (12:00 EST) Week 3	21 Wedding Timelines and Business Cards	22 School Portraits	23
24	25 Senior Early Bird	26 Wedding Marketing Display and Album	27 Reflections Maternity SPTV (12:00 EST) Week 4	28 Bunny Babies LE		

31

My teaching website, SandyPucUniversity.com, uses a four-color system to help students learn how to plan a good solid marketing structure. I start with the date that you want to photograph the session and go back four months. A color-coding system helps you visually organize each project throughout the planning and design, printing, mailing, and booking process. It doesn't matter which colors you choose as long as they are used consistently. As an example, let's say you want to start shooting a baby model search on January 15. First you would go back three months and start mapping out the calendar.

October 15

On October 15, write, "Baby Model Search" in blue to indicate that the campaign is in the design phase. At this point, you decide how to market this campaign. Do you want to send out a mailer, an

SPU
SANDYPUCUNIVERSITY.COM

October 2013

Design Stage Proof/Press Stage Mailing Stage Social Media SPTV

Sunday	Monday	Tuesday	Wednesday	Thursday	Friday	Saturday
		1	2	3	4	5
6	7	8	9 SPTV (12:00 EST) Week 1	10	11	12
13	14	15 Model Search	16 SPTV (12:00 EST) Week 2	17	18	19
20	21	22	23 SPTV (12:00 EST) Week 3	24	25	26
27	28	29	30 SPTV (12:00 EST) Week 4	31		

e-mail, or both? Do you want to post fliers in your community and/or run an advertisement in your local papers? Whichever methods you choose are added to this section of your calendar. Anything in blue should be reviewed multiple times to ensure accuracy; redesigned so that it provides all the pertinent information, issues a clear call to action, and is visually pleasing; and prepared for press. This gives you four weeks to design, tweak, and approve your campaign.

November 15

Next, write "Baby Model Search" on November 15 in orange to indicate that you are in the press phase. Everything in your campaign should be designed and press ready. If you have a printed piece, now is the time to send it off to the printer, allowing the next four weeks to get it back and ready to mail out.

SPU SANDYPUCUNIVERSITY.COM — November 2013

Design Stage | Proof/Press Stage | Mailing Stage | Social Media | SPTV

Sunday	Monday	Tuesday	Wednesday	Thursday	Friday	Saturday
					1	2
3	4	5	6	7	8	9
10	11	12	13 SPTV (12:00 EST) Week 1	14	15 Model Search	16
17	18	19	20 SPTV (12:00 EST) Week 2	21	22	23
24	25	26	27 SPTV (12:00 EST) Week 3	28	29	30
			SPTV (12:00 EST) Week 4			

December 15

Write "Baby Model Search" on December 15 in red to indicate the send-to-client phase. During the next month, you mail out printed pieces and start marketing using the various social media outlets that you have chosen to target the right clients and get the phone ringing. In addition to sending out your formal campaign materials, don't forget to mention it to everyone you meet. This four-week time frame should provide enough time to fill your schedule in a stress-free manner.

SPU
SANDYPUCUNIVERSITY.COM

December 2013

| | Design Stage | Proof/Press Stage | Mailing Stage | Social Media | SPTV |

Sunday	Monday	Tuesday	Wednesday	Thursday	Friday	Saturday
1	2	3	4	5	6	7
8	9	10	11 SPTV (12:00 EST) Week 1	12	13	14
15 Model Search	16	17	18 SPTV (12:00 EST) Week 2	19	20	21
22	23	24	25 SPTV (12:00 EST) Week 3	26	27	28
29	30	31	SPTV (12:00 EST) Week 4			

January 15

You have arrived at your target session date. Your schedule is full, without the stress or frustration of waiting too long or not being prepared. You have clients coming in who have booked for this event and are excited to take part. You are organized, prepared, and enjoying the sessions stress free.

The Calendar System

Now imagine planning a full year's worth of campaigns just like this. Soon you would have every idea that you had mapped out and in an easy format to follow. Following a calendar will become second nature and allow you to spend more time doing what you love and less time finding ways to do it. Some of my most successful students have been using a marketing calendar for years. They start small with basic campaigns and are soon ready to hire additional staff because their business volume increases with every successful idea. You can find more information about my system at SandyPucUniversity.com.

Blogging

A few years ago, it was practically mandatory for everyone have a blog. Now customers spend the bulk of their time visiting social networking sites to search for a quick deal rather than reading blogs. Because of this and the struggle of coming up with meaningful content on a regular basis, many business owners often do not see the benefit of creating and maintaining a blog. But I believe that a blog can be especially beneficial to photographers, because it gives us the opportunity to post beautiful images and tell the story of those images, thus helping us create a relationship with the reader before we even meet. In addition, I use my blog to post links to my site so that potential customers can find me easily.

The trick to a successful blog is developing a loyal readership. Reading your blog should make the readers feel as though they would love to sit down with you over a cup of coffee and get to know you better. You can do this by having what I call an "authentic" blog where you discuss topics that you are passionate and knowledgeable about. You will not find me blogging about the game last night or my enthusiasm for the newest line of fall fashions. My passions are family, photography, charity, and travel, so when I write, it's about one of those topics. To keep my content varied, I like to invite guest photographers from other niches to contribute entries.

Social Networking

You can plan your social media schedule on a monthly, quarterly, or even annual basis, but aim to post at least two targeted marketing ideas on such sites as Facebook, Twitter, and especially your blog. Social media sites always evolve, so it is your job to research the latest trends and stay on top of the wave of Internet exposure.

When you are designing your social media topics, keep in mind that the worst thing to do is focus on what you can sell. People get tired of seeing "buy this now" ads and will stop following you online if your content is not well balanced. Map out your planned posts a month in advance so that you are ready to present a variety of topics and ideas that will provide interest for your followers.

Here are some categories to include:

◈ Business updates (sales, promotions, etc.)

◈ Personal reflections (awards, education, etc.)

◈ Interesting facts (funny stories, community events, etc.)

◈ Informational tidbits (charities that inspire you, client features, interesting trivia)

◈ Session highlights (session descriptions and sample portraits)

> *Note:* *Never, ever post your session highlight images before you sell the session, because doing so significantly lowers your chance for a higher sale. Your client can have Grandma look at the image online and remark how baby smiles just like Mom did at that age; the family members across the country "like" the image and post comments about how big the baby has gotten. You have now eliminated Mom's emotional need to buy the image, because she has the satisfaction of knowing everyone thinks her baby is adorable.*

Although every client whom you work with should sign a model release before you photograph the session, I ask my clients to sign a second one at the time of the sale that acknowledges that I may put my favorites online and that they are okay with my doing so. Of course, you should tell clients that you will notify them when an image is posted so they can share with their friends. Remember, you have already collected payment for the order, so now it is perfectly fine to share it with the world.

Some photographers disagree with me on this, but I am firmly against offering clients a "sneak peek" from their sessions—the sales meeting should be the first time that your clients see the portraits, and if they do not purchase them, it should be the last. As an instructor, once I conducted an experiment on SandyPucUniversity.com with five photographers to test my theory about the sneak-peek approach. I asked each photographer to hold a session, post the best shot from the entire session (the one he or she

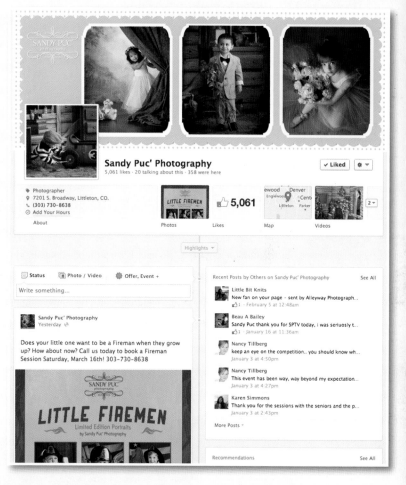

knew would sell) on the business website or Facebook page, and then inform the client that it was there so the client could share it as desired. They all did this, and after the clients came in to place orders, *not one* purchased the preview images that the photographers felt represented their best work. The reason is that once a client has an image in his or her possession, even a Web-based JPEG is good enough to share or print out.

Social media is a wonderful marketing tactic to grow your business when it is exploited properly. But keep in mind that it can hurt you if you do not use it wisely.

No matter the content of your posting, doing a little research online will show you the best times to post and why. Right now, Wednesday is the best day for business posts, and the peak hours are before work, after work, and late at night. Remember, though, trends change, so research new statistics when planning.

You can also add interest to your social media presence by updating your profile image frequently—as often as once a week is ideal. Also, try to post small galleries so that your fans will not lose interest and click away. Studies show that the average person scrolls through four images in a gallery before navigating to a different page. Make sure that your best images are always represented.

With social media, keep it short and sweet! Less is always more. Posts with a maximum of 80 characters have a higher chance of being read, so leave the sagas and go for the strongest thoughts only.

Although social media profiles feature your business information and contacts, you do not own these sites, and they can be shut down or hacked into at any time. For this reason, make sure you create a solid website and/or blog to direct traffic to on a consistent basis. This will help you maintain your presence in a setting that is much easier for you to manage and control.

When designing a website, shop around. Many wonderful hosting companies offer customizable templates that allow you to have a site up and running in just a few dedicated days. Functionality is the most important element of your website. No matter how amazing it looks, if the pages take too long to load or the galleries are sluggish, people will absolutely leave the site. Avoid a cluttered design. Pages should display an equal amount of content and blank space to create a calming and enticing effect. Music on a website is a personal preference for your visitor, so if you are going to include a soundtrack, provide the option of turning it off or muting the sound. Above all, make sure your contact information is clearly listed.

It's a good idea to test your website on a friend's computer or one in a public place, such as the library, to see how it really loads. Your own computer can memorize the codes and cookies and load your site faster after visiting it often, while a computer that has never visited might have to wait for the pages to populate.

The decision to list your pricing information on your site is a personal one, but I don't advise it. I believe that pricing is a discussion to have during a pre-session consultation, when clients can meet you and see your work in person—only then will the true value of your talent be visible. I know that my studio's prices are upwards of three times higher than my local competition, and I would hate for someone to not select me solely because of my price point without giving me a chance to show the value of my work. An in-person consultation ensures that your clients understand your value and are ready to invest in your products.

All social media efforts should be designed to direct clients to your door. If you don't see results instantly, be patient—this marketing approach can take time, but with consistent attention, it will yield amazing results.

The final element to marketing is something that I cover in more detail later in the book, but suffice to say charitable marketing can create a powerful message for your clients, community, coworkers, and even yourself about the type of business that you run and where your priorities lie. By contributing to worthy causes in your area, even if it's just volunteering a few hours at your children's school or donating a gift card to an auction, you will positively position your brand and your personal image.

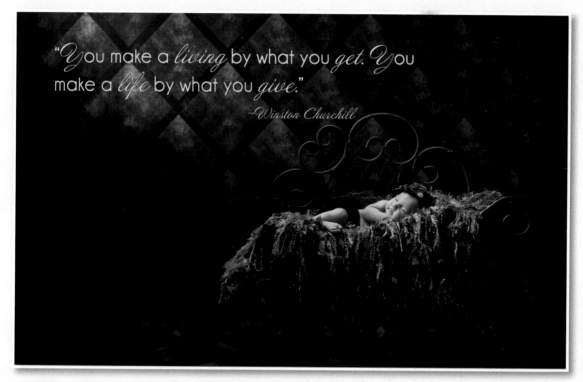

"You make a living by what you get. You make a life by what you give."
—Winston Churchill

Chapter Three

Creating an Efficient Studio

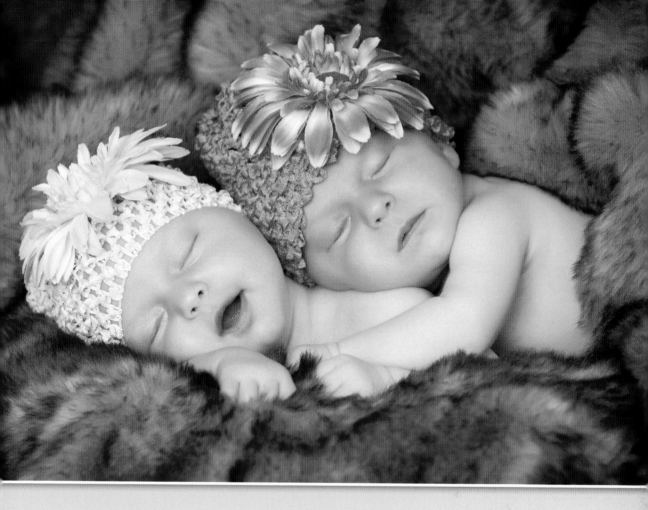

Y ou've created a marketing plan, established a social media presence and website, and organized your efforts into a calendar. This kind of organization greatly reduces the headaches that can arise with the marketing side of your business. This is also true of all aspects of your studio itself, from the behind-the-scenes structure to your pricing and customer-service policies. Everything should be carefully thought out and implemented so that you appear (and feel) on top of your game.

Organizing Your Space

Whether you have a small one-room space to work in or a 10,000-square-foot studio, you can't run an efficient business without first organizing your space. All studios need to have these basic elements:

◈ Reception area

◈ Studio

◈ Dressing room

◈ Production area

◈ Sales room

In a pinch, these spaces can all be in the same room, but the smaller and more compact your work area is, the more organized you must keep it.

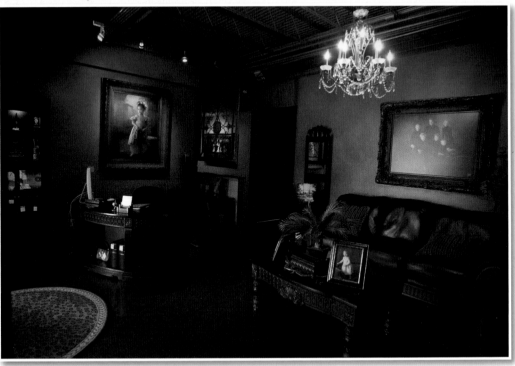

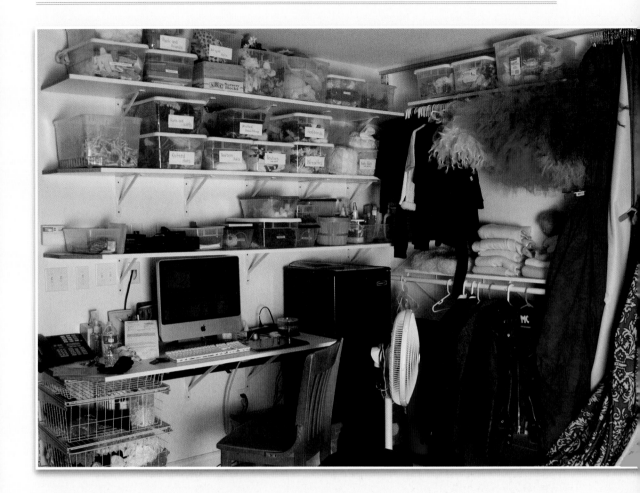

Build an editing station that can easily fit into your studio space. Keep this desk clean and clutter-free, and stock it with any office supplies that you might need. Install plenty of shelving to organize props and wardrobe, particularly the little outfits, diaper covers, and caps that newborns wear the most. Small, clear plastic bins are best for this sort of storage, with each labeled for quick access. These tubs can also store toiletries and supplies that can aid you through any session—everything from nail polish remover, hairspray, cotton swabs, shoe polish, and more should be considered. I order plastic combs in bulk with my studio name and number on them to give as a gift to clients. They are very affordable, and a mother will never feel uncomfortable using a brand-new comb in her child's hair. Offering these small luxuries to your clients makes you seem like an expert at what you do.

Keep a few candy boxes in your studio space to entice children and older toddlers. I recommend Smarties (known as Rockets in Europe and Canada) and small lollipops as the only treats you need. Smarties are a small chewable sugar candy that dissolves quickly and leaves no color in the mouth. The lollipop can be mentioned during the session but saved for the end as the big reward.

For babies, Cheerios and fish crackers are snack essentials. I also keep a small fridge in every studio room and stock it with water bottles for parents. Nursing mothers are always thirsty, so this is an especially good investment for your baby program.

Above all, your studio (and your car, if you do location shoots) should contain a fully stocked emergency kit at all times. My emergency kit is a large toolbox with cantilever shelves, and I have added items to mine over the years that should cover all your bases, and then some:

Cosmetic	Miscellaneous	Clothing/ Accessories	Tools	Children
Bobby pins	Insect repellent	Sewing kit	Tiny screwdrivers	Bubbles
Hairspray	Water spray bottle	Black and white	Pocket knife	Squeaky toy
Hair elastics	Fishing line	shoe polish	Two large clamps	Child-friendly
Combs	Velcro	Contact lens	Two small clamps	snacks and treats
Brushes	AA batteries	solution	Duct tape	
Safety pins	Super glue	Eyeglass repair kit	Allen wrenches	
Mirror	First-aid kit	Shower cap	Pliers	
Lotion	Aspirin/pain reliever		Scissors	
Sunscreen	Black Sharpies		String or twine	
Lip balm	Baby wipes		Cable release	
Lint brush or roller	Rubber bands		Gray card for color	
Calamine lotion	Water bottle		balance	
Nail clippers	Plastic zipper bags		Bungie cord	
Nail file	Warm gloves		Flashlight	
Hand sanitizer	Canned air			
Nail polish remover	Glue gun			
Cotton swabs	Pet treats			
Tissues				

This kit is really a lifesaver for just about any situation, so don't let your supplies run out. Print a checklist with each item that you keep in your kit and tape it to the inside of the lid. If you use something, quickly circle or highlight the item on the list so that you can refresh the items that might be low weekly, or as needed.

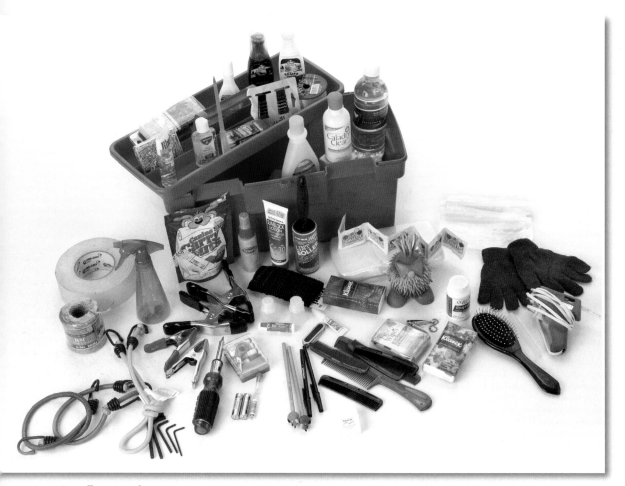

Emergency kit

You can also organize your space by creating a system to store your larger props and furniture. Hooks from a ceiling can be a great way to store chairs. Use a stud finder to locate a sturdy beam to position hooks as safely as possible.

Antique and decorative doors make wonderful backdrops, but they must be positioned securely so they don't fall on anyone. Attach plumbing PVC to the back of the top edge with a nail gun to protect your walls from scuffs as you lean the doors against them. If you opt to use doors as a backdrop, always have an assistant hold the door securely. They are too heavy to be propped near a baby or small child without that safeguard.

Baskets and bowls make brilliant baby props. Make sure there are no sharp or hard edges by lining them with a soft blanket.

Pillows are wonderful as both props and posing tools. A softly colored satin throw pillow can be used for both newborns and high school seniors. Pillows are a quick and easy way to add a pop of color to a scene or give children a few inches of height by seating them on it. Pillows come in huge variety of colors, textures, and sizes, and they are easy to store in bins or closets. I strongly recommend reading care labels to make sure that your pillow can be easily laundered. I have been known to buy absolutely gorgeous pillows that have to be dry cleaned, making me less likely to use them in a session where a baby may have an accident.

You can store larger fabrics that you use for draping, such as tulle, gauze, and blankets, from hangers on a hanger rod. Having all of them neatly arranged in one place saves a lot of time when you have your next great idea or are prepping for a session.

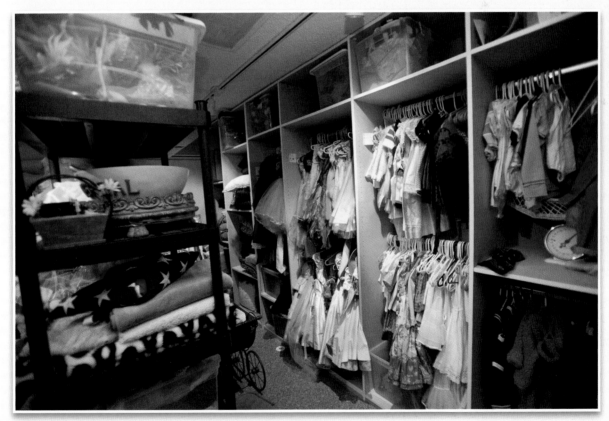

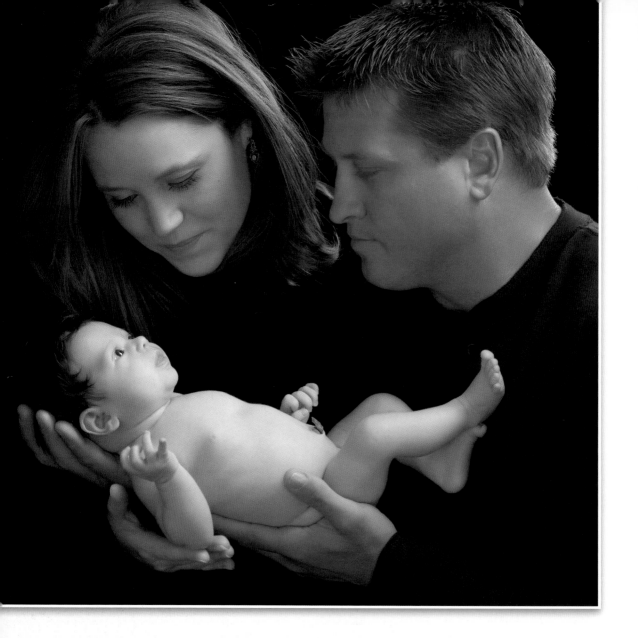

As far as wardrobe goes for the expecting or new parents, gauze and tulle can be part of a set or used to drape a pregnant belly or to create a baby sling. Boleros are another great choice for maternity wardrobe, but they are not in fashion now and can be hard to find. I bought several a few years ago when these cropped knit tops were in style, and the long-sleeved versions are especially flattering on the pregnant form. Most other wardrobe for parents is fairly minimal. Clients usually have their own outfits, but

several backup long-sleeved black shirts in various sizes are always a good idea. Black turtlenecks are a good choice for fathers with heavy necks or hairy chests. I love skin-on-skin portraits, but parents with weight issues always appreciate covering the areas they are uncomfortable with.

When it comes to baby's wardrobe, the sky is the limit. I started with simple overalls and white dresses, and now I have a massive closet of tulle skirts, leather jackets, tuxedos, rompers, fancy dresses, and so much more. Over the years, I have designed set pieces that included baby fairies and angels, but I am still just as happy swaddling an infant in a simple piece of gauze to focus on the tiny features as well.

When creating your sets and gathering wardrobe options, try to create harmonious themes and plan to incorporate three different settings into each session. When creating my sets, I have one neutral setup, another that is based on input received during the initial client consultation, and a final set that is purely my own concept. This takes the guesswork out of generating these moods during the actual session and provides your clients with more variety to choose from at their sales appointments.

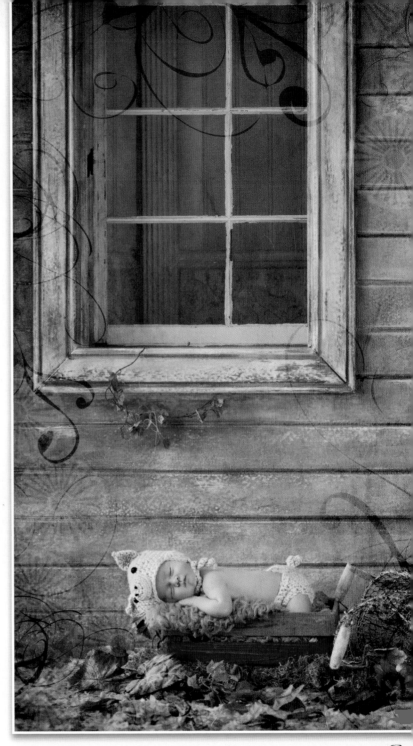

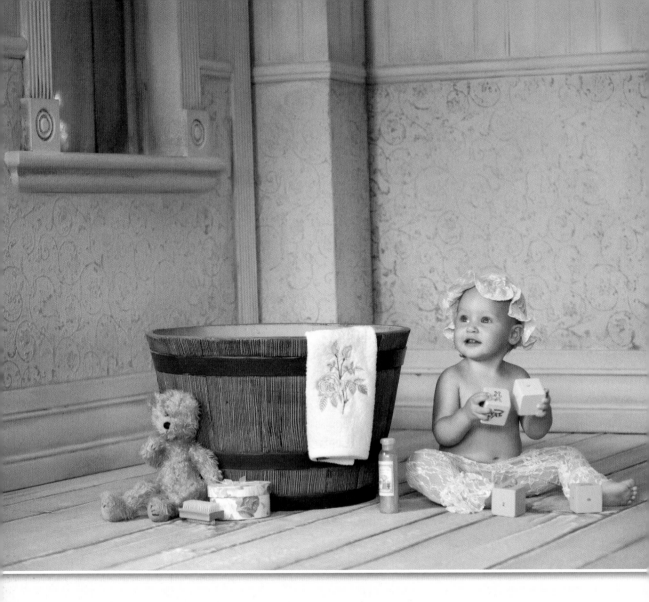

Another key element to the studio space is the temperature. When working with babies, particularly newborns, keep it hot. The room will very likely be uncomfortably warm for you, but for less-dressed clients, particularly little ones, this is going to be the most desirable temperature.

Newborns tend to respond better to a very warm environment, and I try to never take a baby from a warm blanket and put him or her onto a cold piece of furniture. A heating pad set to low heat and wrapped in a soft piece of flannel is a great way to keep little ones warm while posing on furniture.

50

Never place a baby on a heated surface without first testing the temperature with your hand. You need to be creative with draping fabric to hide the pad and cords, but it is worth it, as the heat helps calm babies down. In a pinch, I may use a hairdryer to warm up a cold surface. You just need to always test anything that you have warmed with the inside of your arm to make sure it's not too hot! Safety is always the most important element to consider. If you want to avoid heating up the entire room, small portable heating units are a great idea. Keep safety in mind at all times—if young siblings could touch them while you're busy taking pictures of the baby, avoid the risk.

Setting Your Prices

This topic is always difficult for any businessperson to address, particularly a photographer, who typically is self-employed and is creating a personal expression. Most new photographers are inclined to undercut their prices to attract clients and then later feel guilty raising their prices even to the level of covering their costs. This was how I felt years ago, but if I hadn't realized the true cost of doing business and the true value of my work as an artist, I wouldn't be able to do what I love today.

You must respect the time that you invest in your work. If you don't, how on earth can anyone else? Think about the people whom you are away from while you are working and consider how truly priceless that lost time really is. Beyond that consideration, it's just as important to recognize the true cost behind every single product that you sell.

To determine the cost of sale (COS) for any one item, you must consider everything that goes into making the finished product. You can actually walk through your studio and go step by step through the process to determine the true cost of bringing any one item to completion. This includes fixed costs, which do not vary with the amount of business that you do, and variable costs, which do increase or decrease with your session counts. Here are some examples of each type:

Fixed Costs	Variable Costs
Tools	Materials
Equipment	Labor
Taxes	Advertising
Utilities	Packaging

The reality of these costs might surprise you when you fully take them into account. You might realize that you aren't breaking even with your current pricing structures, let alone making a profit. After these costs are considered, add a profit margin. This can be done on a percentage basis or a fixed amount, but either way, you must settle on a price that the market will bear and that will help you reach your goals. To determine what your demographic will pay, you may want to "shop" your local competition and see what they are charging for similar products and services. Then you must honestly look at your work and ask yourself what sets you and your studio apart from the competition. If there is no difference between what you and the studio down the street offer, then your prices cannot be much higher than theirs. But an educated and talented photographer who provides outstanding customer service and amazing images may be able to charge up 200 percent more than the competition and keep his or her schedule full.

You might be surprised how understanding your clients can be when you raise your prices. Some might be disappointed because you no longer fit within their budgets, but if your business is going to improve, you need to part with the people who aren't going to help you grow. I struggled with this concept for years, because I loved my clients and wanted to always please them. It was only after I had sacrificed too much time with my own family that I realized that not every client was *my* client. If you charge fair prices for your time and talent, there are sure to be people who are eager to pay them. Confidence is key to this transition process, as is openness with clients who are unhappy to see prices go up. If they ask you why your price structures are changing, tell them the truth—that you weren't charging enough to cover your costs. This explanation is only necessary for current clients, and the ones who value your work will stay and continue to refer others to you. Those new clients will be happy to pay your prices, never knowing the difference.

Once you have set your prices to help you cover your costs and reach your goals, it's time to consider how you want to present these costs. I have found time and time again that packages are a great way to encourage clients to spend more, as they offer a better value. Set higher à la carte prices to discourage small purchases. Offering bonus items with packages is another great way to encourage higher spending. The lowest package on your menu should be the minimum you can earn to be profitable, while at least two or three other options are set at higher prices to create something for everyone. It might seem odd, but what seems like a pie-in-the-sky package might be the perfect choice for some clients, simply for the fact that it meets all their emotional and physical needs for that session.

About eight years ago, I devised a unique credit system to sell portraits, which gives clients the opportunity to think in terms of credits rather than dollars. A credit system is another way to deemphasize the prices of packages and à la carte items by affixing a dollar value (be it $5, $10, or $15) to a single credit. Suddenly, the prices become less of a central concern, and clients begin to relax and build their

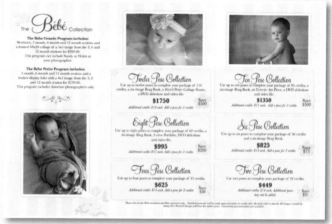

"dream orders." In photography sales, it's much easier to take items out of the shopping cart at the end if clients are concerned about the bottom line than it is to try to get them to add more to the cart later, and with the availability of payment plans, many clients opt to pay in segments rather than part with items that they had their hearts set on.

I have been teaching the credit system at SandyPucUniversity.com for more than five years, and thousands of studios have switched over to this unique and appealing way to handle the sales process.

The way you present your pricing also affects the way your clients spend. A well-designed pricing guide is an important element to any portrait studio. My baby plan marketing kit includes a pricing menu that can be offered to clients in their initial pre-session consultations to give them an idea of the pricing options and products I offer. The design of these pricing guides should be simple, with plenty of visual space. This is also a good place to include your studio policies and disclaimers, whatever they may be, so that if a client starts to complain that she didn't know about a policy, you can show her that the policy is there in print. That usually resolves such issues on the spot.

Print your pricing guide in smaller quantities than your business cards and other marketing materials, as your pricing is likely to change frequently—some popular items may need to go up in price, some less popular ones may need to come off the list altogether, and so on. Don't tie yourself down to any pricing structure by printing thousands or even hundreds of any given pricing guide at one time. It is also wise to include the date when a pricing guide is created or updated so that a client can't bring in a brochure from five years ago and expect you to honor the older prices. If you want to test a pricing guide, gather a few of your friends and best clients to serve as a focus group and get their honest input.

You also need to decide whether you are going to charge a session fee. I used to feel uncomfortable collecting this fee upfront and often ended up not getting paid for my time. When I hired my first receptionist, who had previous experience at a portrait studio, she had no trouble collecting these fees upfront, and I was pleasantly surprised to see that none of my clients minded paying in the least. Whatever you do, *don't* waive the session fee, and make it nonrefundable. Time is one of your most valuable resources. Even if you charge a fairly small fee, getting something for your time is better than nothing, and making it nonrefundable is likely to reduce the number of no-shows and rescheduled sessions dramatically. Of course, there are always emergencies, such as a sick child, and you will want to set up policies to address that. At my studio, a client can cancel the day of the session with no repercussion one time for a sick child but must reschedule within thirty days.

You have several options for session fees. You can charge a low session fee and higher product prices, but this approach often entices clients who then may not be able to afford to make large purchases. If you charge a higher session fee and lower product prices, you are essentially "prequalifying" your clients, because they are obviously willing to pay for your time—but this practice can also limit the number of people who will actually book a session with you. Some studios charge high session fees *and* high product prices, but they tend to cater to a very select clientele and have established reputations for quality in their community; if you are just starting out, this approach can be a lot to ask of new clients who haven't seen your work before. These prices also require you to provide an extremely

customer-oriented experience, because it's the extra perk that clients are paying more for. Your policies will develop over time, but here are a few customer-service considerations that can help you no matter where you are in the process.

Customer-Service Policies

I cover various elements of customer service throughout the book, but you should apply a few basic protocols in any situation. It may require serious effort at times, but the key to good customer service is this: when it's hardest to be nice, it's also most important. This belief doesn't mean you should be a doormat with clients who are most difficult to work with, but you should always maintain a professional and friendly composure.

Here is a list of banned words at my studio, because I have found that these words are an instant turnoff to clients seeking an upscale experience:

Banned Words

Shoot: I do not shoot people, I photograph them.

Viewing session: This sounds like someone passed away.

Sell: Clients invest, I do not sell to them.

Picture or photo: I create portraits, I do not take pictures or photos.

Digital files: I do not sell digital files, but clients can invest in archival images.

Pixels: I never talk about what size a file is.

As you can see, careful word choice alone can make you sound more professional. As an artist, it is important to remember that sometimes *how* you say something matters as much as *what* you say.

When working with clients, it's also important to stay positive and energetic. Positivity is infectious and should be a key feature of all employees who work with your clients directly.

When you have a difficult client experience, whether he or she is unhappy with a session, a staff member, or the final product, the best way to handle it is to stop what you are doing, give the person your undivided attention, and just listen to everything the client has to say. Once the client has gotten it all out, show empathy and then reiterate what you have heard to assure your client that you understand the issue fully and that you are interested in his or her feelings and achieving an outcome that will please everyone. These simple steps can turn a livid individual into a calm, loyal client who returns to your studio time and time again. People want to be heard and respected. If you demonstrate that you can extend this courtesy, even when clients are upset, that act alone can be very impressive.

Once you understand the issue, how you deal with the situation is up to you. If you or someone on your end is to blame, then a sincere apology is due, along with any other gestures to make the situation right again. In most cases, this does the trick. Other times, you truly won't be able to please some clients. That is unfortunate, but it happens in every business from time to time. Don't take it too hard. Just know that in the end, this approach will help you retain most clients, even in uncomfortable situations. On rare occasions, clients might try to take advantage of you, try to bully you into giving them a deal, or disrespect you in some way. When this happens, it's your responsibility as a business owner to handle these situations firmly and tactfully. Sometimes the only thing you can say is, "I'm sorry, but it doesn't seem like we can help you any further." There's nothing wrong with that—it's just part of doing business.

You should also consider separating your main phone line from your reception area, whether you are operating in a larger space or an in-home studio. The ringing phone is a distraction to a receptionist, who often has to choose between helping a client over the phone or in person. A behind-the-scenes call center and/or a frequently checked voicemail account is a better way to handle this dilemma.

Making a professional impression is important, from the dress code at your studio, to the interior décor, to the branding on the materials that you give your clients. Here are samples of a few essential documents to help you stay organized and make positive first impressions:

◆ Appointment card

◆ Client intake form

◆ Model release form

◆ Schedules

◆ Baby plan welcome packet

◆ Balance-due letter

◆ Client thank-you card

These documents are easy to create and update, yet their unseen result is a client base that respects and trusts you from the get-go, because you are organized and professional.

The final key element of good customer service is to always follow up. Every step of the way, you should be in touch with your clients, reminding them of their appointments and becoming prominent on their radar. The pre-session consultation, photography session, sales meeting, and order pickup should all be preceded by a reminder phone call and e-mail. I use prewritten e-mail templates from Ukandu.com that are sent out to the client before each of the baby sessions at three, six, and

twelve months. These e-mails highlight the different milestones that the baby should be reaching, featured products for that particular session, and steps parents can take to prepare for the session. These help clients not only remember their session dates but get excited about them.

Once an order is complete, mailing out a client survey with a self-addressed, stamped envelope can provide your clients an opportunity to offer praise for the elements that they enjoyed and suggestions for areas you need to improve. Both are invaluable, and although you won't get every single survey back, the ones you do receive can be very eye-opening. I get some of my best testimonials from these surveys, and I also get some negative feedback as well. As scary as asking for feedback sounds, getting a negative comment gives me the opportunity to contact the client, apologize, and try to make it right. If a client is willing to share his or her concerns, this usually means that the client wants to continue the relationship and not just walk away, and I want to convey that I care about the opportunity.

Sending a thank-you card after the session from the photographer, after the purchasing session from the salesperson, and after the delivery from the receptionist is always a must. If you are a sole proprietor, you can send one at each of these stages as well. This long-lost tradition used to be commonplace in personal and business circles. A personalized message goes miles in showing your clients that you appreciate their business. Several e-mail templates and designs on Ukandu.

com feature beautiful quotations that I use on a daily basis. However, a handmade or store-bought greeting card can be just as meaningful. Demonstrate your genuine appreciation for your clients with these customer-service protocols, and they will become loyal, lifelong patrons and friends.

Sending out three cards in a short time period, particularly if you are a one-person operation, may be difficult to accomplish. Another option is to send a quick thank-you e-mail after the session that also reminds the client of the upcoming sales appointment, a physical card following the sales session that sincerely expresses your delight in working with the client and how much he or she is going to enjoy the specific products purchased, and then a final thank you after delivery in the form of a Facebook timeline post or a set of Web images for the client to share with family and friends.

Thank you for allowing Sandy Puc' Photography to serve you and for the confidence you've placed in us to create your family's portraits. We strive to provide the best possible service and do all we can to earn your *continued trust*.

Your *friendship* and *good will* are the foundation of our success, and we want you to know that you are appreciated.

THANK YOU FOR YOUR BUSINESS.

SANDY PUC
photography

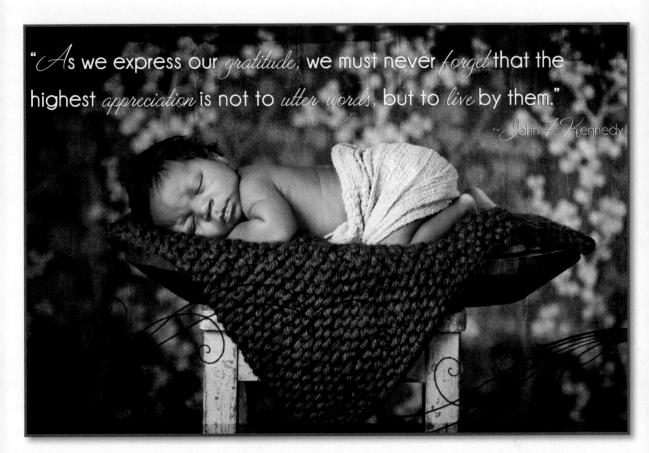

"As we express our *gratitude,* we must never *forget* that the highest *appreciation* is not to *utter words,* but to *live* by them."

~ John F. Kennedy

Chapter Four

Pre-Session Consultation

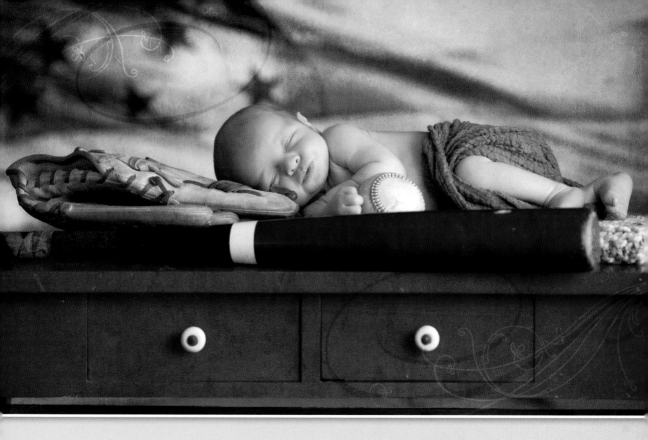

A good pre-session consultation is an important step in any portrait process, but many photographers rush through it or skip it altogether. Don't underestimate the importance of this critical step—not only does this consultation introduce your clients to you and your studio, it also prequalifies them so that if your pricing is not in line with their budgets, they won't have to go through the session and then feel torn because they can't afford the images. This also prevents you from feeling guilted into offering discounts in those scenarios. A well-executed consultation provides you a better idea of what your clients are looking for so that you can create the sessions of their dreams. More than anything, this session allows you to educate the clients. The more involved they are in the process, the more they will want to invest in the outcome.

When people call to request price quotes, invite them instead to come in for a short, complimentary consultation. This meeting provides them with a better idea of what your work looks like, pricing options, and session types. Many people then schedule a consultation, but some persist in asking for a pricing sample, saying, "Well, I just want to get an idea." There are many ways to answer this, but many photographers have a knee-jerk reaction to quote their lowest package price. Resist that urge, because your lowest package may not suit their needs, and they will feel misled. Instead, offer a price range, starting with your mid-level package pricing and ending with the highest-priced package. Say something like, "Well most of our baby-program clients spend anywhere from X to Y dollars on a portrait session, but what is your budget?" This response answers their question while putting the ball back in their court. If they quickly get off the phone, that is their way of telling you that your prices are too high for them. That is okay, because not everyone should be your client.

After hearing over the phone that they are too expensive, another common reaction among photographers is to quickly offer

a discount of some kind to keep the business, but this response isn't wise. I used to do that as well, looking at it as a way to prevent money from walking out the door. It is important to overcome this mind-set. Remember, this is a person who has not met you or seen what you have to offer yet has already decided that you are not worth the money. If you offer unqualified clients special deals, you are paying the ultimate price by sacrificing your time—the most valuable resource of all. Instead, graciously let them go and keep your schedule open for your target market.

A scheduled pre-session consultation gives you (or a salesperson on your team) the chance to meet your clients in person before their session dates. The experience should be very warm, personal, and open. You want to really wow your clients during this meeting, so present a slideshow of sample baby or maternity images to give them a good sense of your shooting style, set options, and themes. This is also a great time to show samples of your best-selling products for whatever session type they choose.

Discussing specific products is a great segue into pricing. You should be very forthcoming during this meeting regarding your various packages, prices, and payment options. It is imperative that you be confident in your pricing, present it for what it is, and do not apologize. Prospective clients may pick up on uncertainty and try to bargain with you. I had one prospective client tell the salesperson that she wanted specific items and was willing to spend X amount of dollars, and my studio could take it or leave it! Obviously, my business was not the studio for this client, and my salesperson encouraged the individual to check elsewhere.

For baby plan clients, only one initial consultation is necessary, so my consultation slideshow contains images from newborn through one year, along with samples of completed Bebé collages, folios, and other art products. Many times, if parents are on the fence about signing up for the entire baby program, this presentation helps make up their minds. After you have presented your portrait, product, and pricing information, take the time to just listen to the clients and note what they are looking to capture during the year. Many times, this meeting is when I learn about specific details, such as a quilt that Great-Grandma sewed with baby's name on it, and we make plans to incorporate it throughout the year. Very popular among my younger clients (even though I find them a bit trite) are the images of a three-month-old lying near a very large stuffed animal, then a six-month image showing the baby sitting up next to that same toy, followed by the final image in which the one-year-old is now

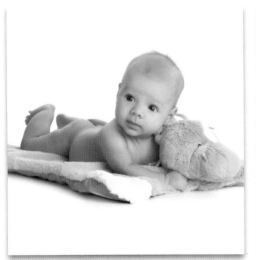
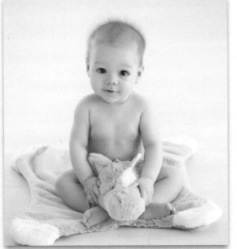
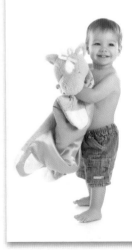

taller than this furry friend. Most of my clients don't know they want a set of images like this until they see it in the consultation slideshow, but this type of planned series is certainly something you need to know about from the very first session.

If they wish to book a session, this is the time to collect the upfront session fee or, for baby plans, the entire purchase price. Your clients should leave with several forms of literature, including:

◆ A "What to Expect" brochure

◆ Pricing guide

◆ Appointment card

These materials help your clients revisit the information that you covered during the consultation, and for new mothers, the "What to Expect" guide is a great help in reminding them what to bring and how to prepare for their sessions. Again, the e-mail reminders are another great product to use, but those should go out a day or two before the actual session dates. This process may seem like a lot of homework, but these extra measures show your clients that you take your work seriously and have covered all your bases. These steps also prevent a lot of misunderstandings and headaches that would otherwise arise along the way. When you take the time to educate your clients, they see added value in their products and have a better overall impression of you and your business.

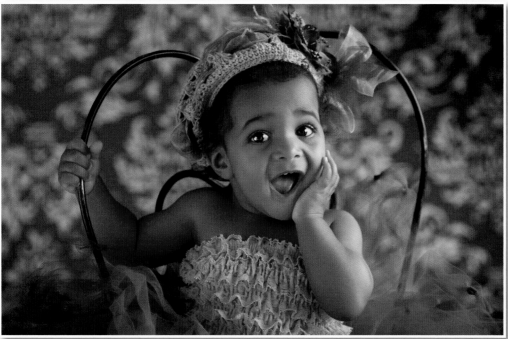

Chapter Five

Lighting Setup and Session Preparation

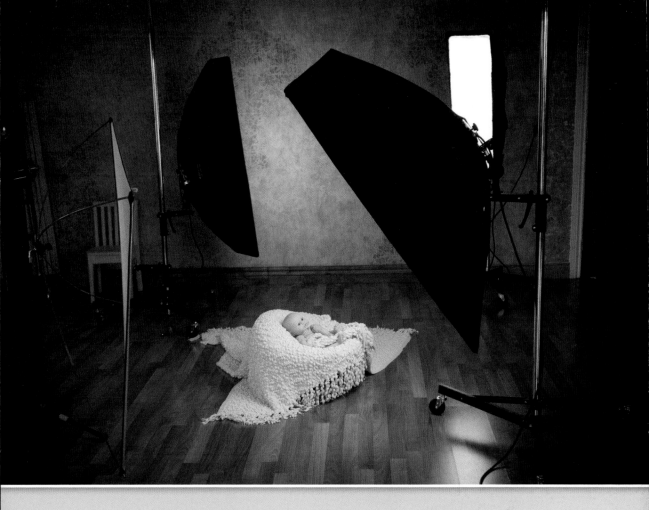

Of all the elements that combine to make a good portrait session, proper lighting is one of the most important. The more you understand how light works, the better you will be at using it to create flattering, emotionally charged, evocative portraits. Anyone can pick up a camera and take some pictures. But a skilled photographer has the know-how to turn life's simplest moments into art. Nothing sets a professional photographer apart from an amateur shutterbug faster or more distinctly than the proper use of lighting. Properly outfitting your studio requires a significant investment of time and money, but with the right tools and techniques, you will be prepared to create stunning work that you can be proud of. This chapter discusses basic session preparation you should complete each and every time you photograph a client.

The first piece of equipment that I recommend for portrait sessions with babies is a camera stand or tripod. Many photographers prefer to be "free" of this type of equipment, because they can be very cumbersome. I also felt this way as a younger photographer. However, struggling to work with my tiny subjects while holding a camera was impossible. Additionally, as my cameras and lenses got more sophisticated (and expensive), I found that I simply was not strong enough to hold my camera stable on my own, especially throughout an entire session. I now swear by a Studio Titan for my in-studio work and a Manfrotto 058B tripod with a #222 joystick grip for outdoor and location shoots. Both of these products are top-of-the-line and deliver smooth, dependable, and easily adjustable stability. Because I am confident that my equipment is secure with these tools, I am free to move more quickly and confidently through a session. That said, I do take some time near the end of most sessions to capture unique angles and effects without the help of my camera stand or tripod. But I am pretty comfortable and casual about these shots, knowing that I got a great collection of poses during the bulk of the session.

Studio Titan

Manfrotto 058B with #222 joystick head

Another essential piece of equipment that I use is a Pocket Wizard, which remotely fires the lights and reduces the number of cords that my clients and I could trip over. A meter is another key piece of equipment for any photographer to master using to properly control the light.

Pocket Wizard transmitter

Sekonic light meter

Light stands are, of course, also very important. Over time, you will find a brand that you like to use. My favorite is Manfrotto adjustable poles with a wheelbase, because they are so fluid and easy to adjust. It's important to be able to lift or drop a light quickly during a session, particularly when working with babies, as they get fussy and you have limited time. A good light stand doesn't get in the way of your work.

I employ many different lighting sources during the average session. Typically, I use equal amounts of strobes and continuous light. Many photographers are becoming more interested in natural-light photography, shying away from the use of artificial lighting sources. I do use natural light, but the disadvantage to

Manfrotto light stand

using natural light exclusively is that it can be hard to get a good focus as well as generate enough light in an indoor studio. A combination of both delivers amazing results, regardless of the setting or time of year. Seasons are important to consider, because with a baby plan, you are working with different types of light throughout the baby's first year. In the spring and summer, you see a very warm natural light. However, in the fall and winter, the ambient light has a much cooler, blue hue to it. This isn't necessarily bad, but because I offer a three-image framed art piece or folio at the end of the program, it's important to use a strobe to help maintain a consistent skin tone and mood throughout the year. It is nearly impossible to create a harmonious look if you rely on natural light exclusively.

Photogenic Professional Lighting strobes and Westcott's TD6 continuous lights are my go-to choice, but I also use a variety of other tools to manipulate the light to accomplish the effect I want. Soft boxes, strip lights, reflectors, egg crates, and honeycomb grids are all fundamental lighting accessories. I use them differently from session to session, depending on a variety of factors, but I recommend that you have them all on hand.

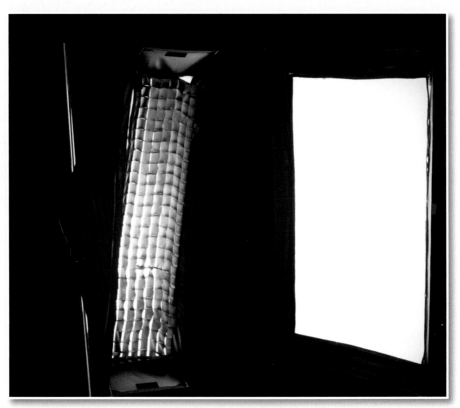

Strip light with egg crate modifier and soft box

Another consideration for session preparation is your backgrounds. When I was starting my business, I was inclined to invest in only a few. The best ones to start with are white, gray, and black. If you are just getting started, resist the urge to buy a funky, unique design, as this background is not going to be versatile enough to use with every session or every client. Once you have the basics, you can gradually add more colors and designs. Silverlake and Westcott are amazing sources for well-made, easy-to-use backgrounds.

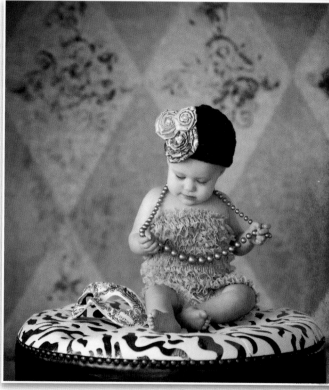

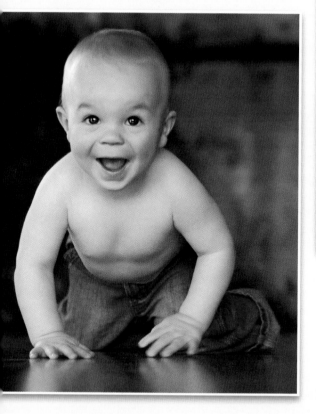

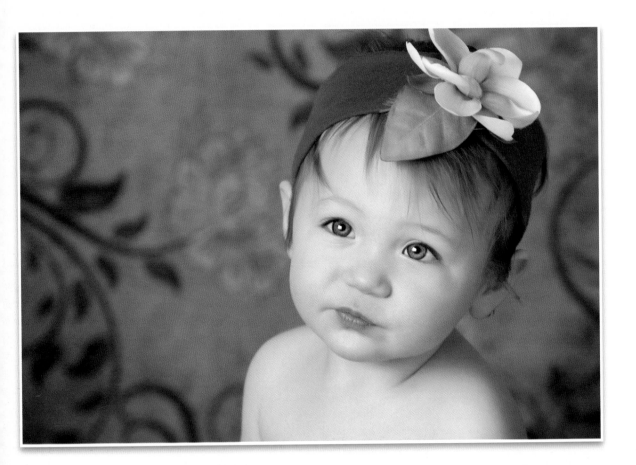

Depending on the type of backdrop in use, you also want to be sure to cover the floor with a thin plastic covering of some kind. In most baby sessions, the child is bare, so expect some accidents. You can protect painted and roller backgrounds and your flooring with a plain vinyl tablecloth. I like to cover a clear tarp with fabric so that it doesn't show in the portraits, and it makes the floor less slippery to walk on. Cloth backgrounds can usually be thrown into the washer, so I don't have to worry about protecting those as much.

Last, but not least, be sure to color balance before each session. A Photovision Digital Target is a great tool to help white balance your cameras. This step also helps you immensely in the workflow process, as you can apply one alteration to an entire set of images in one step and know they will all be color balanced.

After you've made these preparations, it's time to start shooting!

Photovision Digital Target

A Basic Lighting Setup

Available Lighting

One of the easiest ways to understand lighting is to use natural available light. A large window (north facing is best, because it provides the most consistent, even light) and a simple reflector are all you need to get started. Learning how to effectively use shadows is important. Shadows create shape and depth and prevent a flat and boring final image. If you know you will be working with a baby, take the time to use a similar-size doll and practice different angles and poses to find the best quality light. The more you practice, the more you will "see the light." Once you have mastered working with a doll, find a friend to hold the doll and practice shooting mother/father baby images as well. Practice makes perfect—the more time you invest before you work with a client, the less stress you will have once you have a real active baby and a new mom in front of you. Remember, babies can be tough. They cry often, and when you add tired, stressed-out mothers to the mix, you are going to be working hard. The more you know and can anticipate in advance, the better and more professionally the session will go.

73

Too much light flattens the image.

Too little light makes the image overly contrasted and dark.

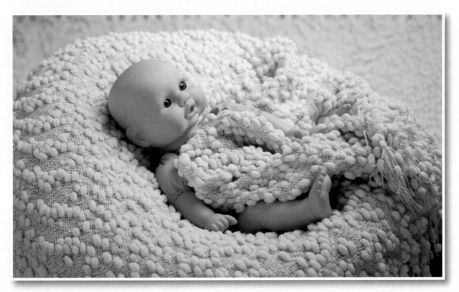

Balancing the light and shadows gives the image depth and dimension.

Although I do work with natural light often with my baby portraits, as I mentioned earlier, over the years my style has evolved to include multiple lights to create depth and dimension. Nowadays there are more photography businesses than ever, but I believe that using professional lighting separates me from my competitors. Properly lighting a session is a skill that takes time to master, but trust me—your clients will recognize the difference in the final images.

A typical setup for me includes a main light aimed at the subject, a kicker (or separator) light coming from behind located opposite the main light, a background light, and a reflector also located opposite the main light. This configuration gives total separation between the subject and the background, and these lights can be used to add depth and dimension in the final images. I use both strobes and continuous lights, depending on the effect I want, and I can easily switch between them during a session.

In addition to the tried and true lighting setup that I typically use, I sometimes experiment with other light sources. Strong video lights and even simple chicken-warming lights often do the trick. Safety is important when working with babies, so have a plan for your lighting and someone to help you as well.

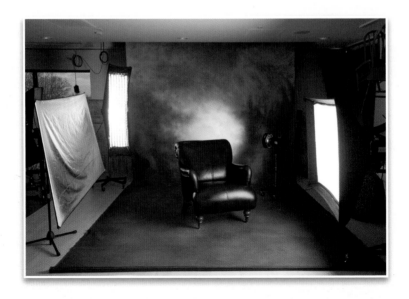

Basic Lighting Setup

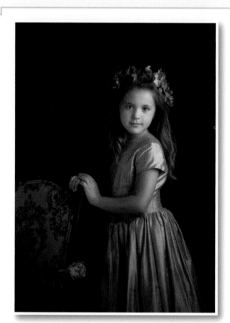

Main light only

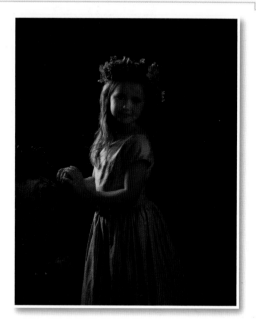

Kicker light only

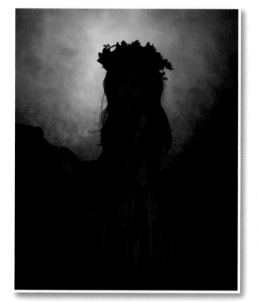

Background light only

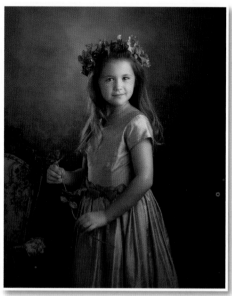

Image using main, kicker, and background lights

Chapter Six

Discovering Your Style

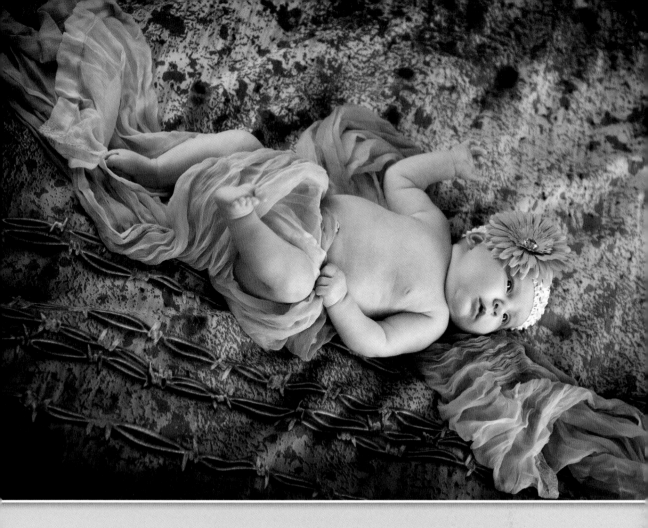

Before I break down the actual sessions, I want to talk a little bit about finding your unique style. Today, many photographers feel pressured to offer their clients a wide range of looks and styles to choose from. This is a nice ideal, but it's a bit like one restaurant serving gourmet French, Mexican, Italian, Japanese, Indian, and . . . well, you get the idea. You can't be the best at everything, nor should you try. As an artist, you owe it to yourself to find out what you are good at, what your photography looks like, and then enhance it, perfect it, and own it. Whether you are more inclined toward whimsical outdoor portraits that feature blurred, ephemeral backgrounds and timeless poses or you prefer formal studio work with dramatic lighting and stylized poses, you should be proud of your style.

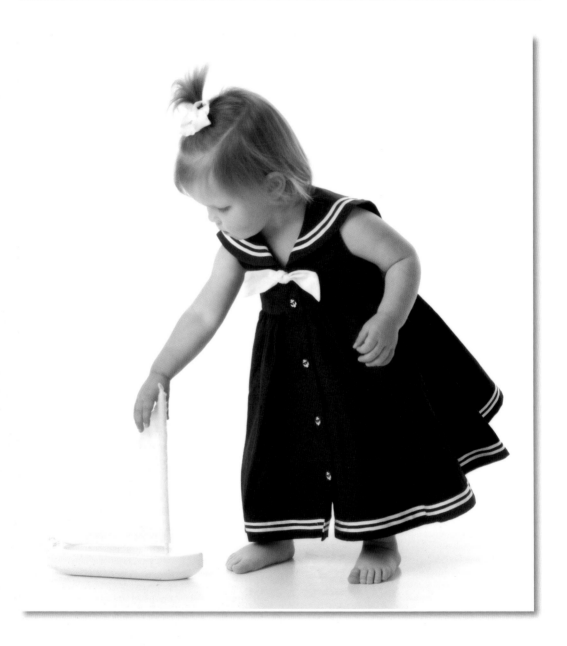

When I began photographing babies, I loved using a plain white background and minimal white props. My style was very clean and very simple. As time went on, I began adding simple touches, such as a flower here, a colorful pillow there—nothing too extreme. Then I began building small sets that incorporated suitcases, baskets, and little nests constructed from colorful fabrics, and I loved the results. I tried to never restrict myself to what I had done in the past, because as I expanded my horizons as a photographer, my style changed to accommodate my new knowledge and confidence. Now my style is still simple, but colorful. Over the years, I have refined my personal taste as well as following current trends.

Take the time to discover your style by setting aside a few consecutive days to dedicate solely to photography. Use friends and family as models or even strangers at the park, beach, or hiking trail. Just go. Let your energy guide you and don't overthink the process. After a few days, review what you've created. Look for underlying elements that are consistent throughout the images. Select features that you like and others that you want to improve or do differently altogether. This process will gradually help you find your style.

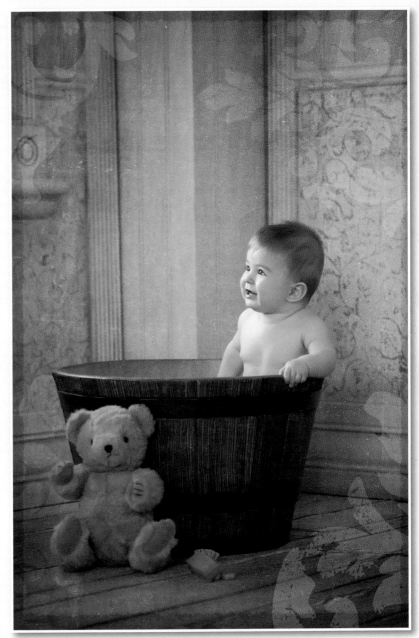

Japan

Turkey

Once you are confident in your own style, don't neglect it. Dedicate a weekend each year to rediscovering and evolving your photography aesthetic. I like to pick a random new destination across the globe and spend seventy-two hours simply shooting. I try out new lenses and techniques, just playing around and having fun with the process. Over the years, I've visited England, Greece, and Turkey among many exotic destinations. Each trip has been an adventure that yielded lots of hidden treasures. Although I am technically not practicing working with babies during these excursions, I believe they help expand my creativity, and ultimately I see the results shine through my work when I am back home in my studio.

London

Greece

83

China

Although you might not be up for a trip to Norway, you can still make time to explore and expand your talent. Here are some fun suggestions for quick getaways that can help you experiment with and develop your style:

◈ Local state or national park

◈ Nearby city

◈ Zoo or animal refuge

◈ Botanical garden

◈ Ranch or farm

◈ Outdoor marketplace

◈ Amusement park, fair, or carnival

◈ Airport, bus, or train station

◈ Local racing or sporting event

Changing your destinations helps you stay out of a rut, and going to new places is always a lot of fun. This list of suggestions is just a starting point. Get creative and think of sites that interest you. The goal is to find places where you can click away to your heart's content. Just because you are a working photographer doesn't mean you can't still have fun with a casual shoot.

My staff members still tease me about the evening they found me lying on the curb outside the studio, photographing flowers that I was holding between my toes as I held them up to capture the light from the sunset. It was silly, but the final image was a personal favorite. You will discover more than you expect when you take time to examine your work and yourself. You deserve it!

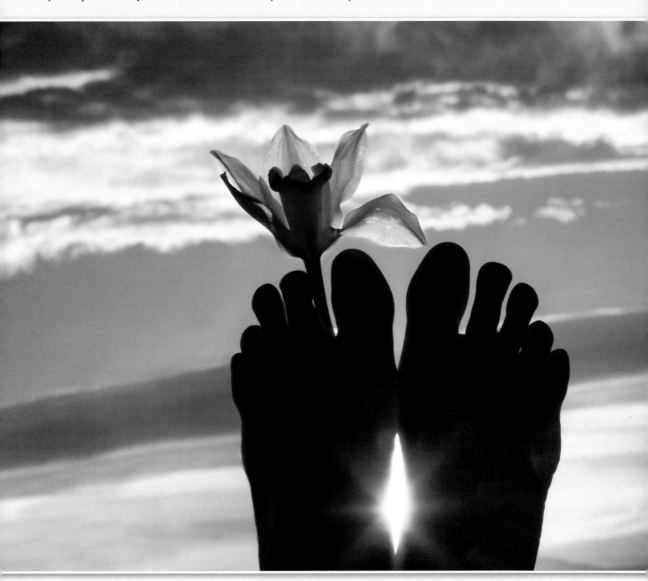

Chapter Seven

The Maternity Session

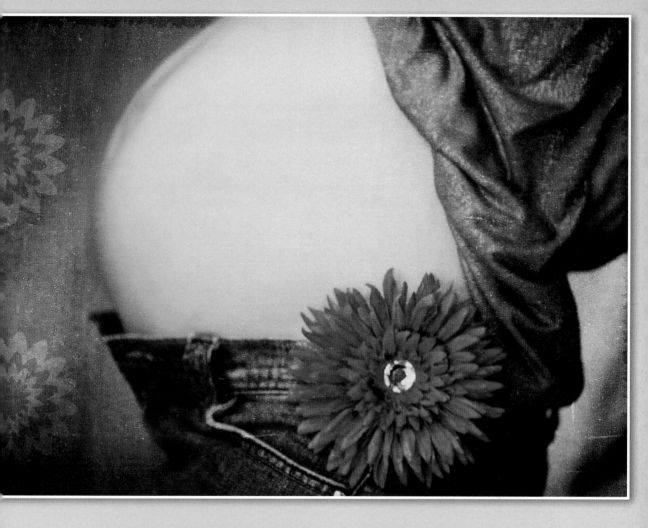

Nothing generates a baby plan client like a great maternity portrait session. If a pregnant woman trusts you to document her growing body artfully and beautifully, she is sure to trust you with the memories of her new arrival. The catch is that you must execute this session flawlessly, both in your results and your client experience, to ensure that it leads into a baby plan purchase.

Pregnancy sessions, or maternity sessions at my studio, are best when held between seven and eight months, depending on how your client's belly is developing. The general rule is that you want the belly to have extended past the breast line so that your client looks genuinely pregnant and not just large. If she isn't showing much, it's best to wait a few more weeks to get the full, round belly that these portraits show off. If a client is already showing quite a bit but is still fairly early in the pregnancy, it can pay off to reschedule the session for an earlier date to capture the belly when it is firmly round but still manageable. The larger the belly gets beyond a certain point, the harder it is to create a balanced, harmonious look. It also becomes more difficult to convince an expectant mother that she looks amazing and to feel serene and confident the closer she gets to her due date. She also gets progressively uncomfortable as she struggles to get around late in the pregnancy.

Scheduling a pre-session consultation will help you get the timing right and get on the same page with your client as far as her expectations go. Maternity portraits vary widely. There is no right or wrong style, but it is a good idea to show clients a few samples to see which approach appeals to them the most.

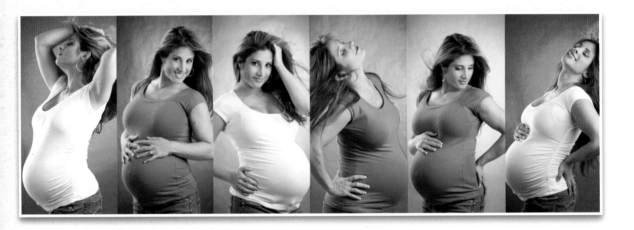

Traditional maternity portraits are the best choice for families who want to include siblings, as the subjects typically are fully clothed, and the poses are fairly minimal. I like to say that these are nice enough to show Grandma. It can be more difficult to show off the baby bump when it is covered in a shirt, but with the right background and lighting, it can be done. With heavier subjects, this style is even trickier, because the wrong clothing can just make your client look heavy rather than pregnant. Play around with backgrounds and lighting if this is the style your client prefers to find a good balance between highlighting the belly and minimizing problem areas. Always remember that dark clothing and a dark background create a slimmer look, while lighter clothing and a light background accentuate size. If your mom-to-be looks and feels fabulous, anything goes, but if she is feeling heavy and uncomfortable, darker choices are best.

At the other end of the spectrum are clients who want very dramatic portraits in which they are fully nude and highlighted with creative lighting and posing. These are beautiful sessions, but covering the necessary areas while highlighting the belly and face can be very challenging. Some photographers aren't comfortable with this approach, and male photographers in particular may find it a bit unnatural at first, but if you are completely professional in your attitude, the clients pick up on your confidence and calmness, and you can work together to create some amazing images. However, if you or your clients are not comfortable, it's best to simply work with partial clothing or wraps.

Fabric wraps are a nice bridge between the traditional and artsier session types, and I find that most of my maternity clients love the portraits that I can create with them. I like to use gauze, tulle, and fabrics with a bit of shimmer and drama. Play around to see what works for you. Regardless of the fabric, you can use a small section to fashion a bra top of sorts. Add a button or other embellishment in the middle, or simply tie a knot to serve as the front of the bra, and then wrap the sections around

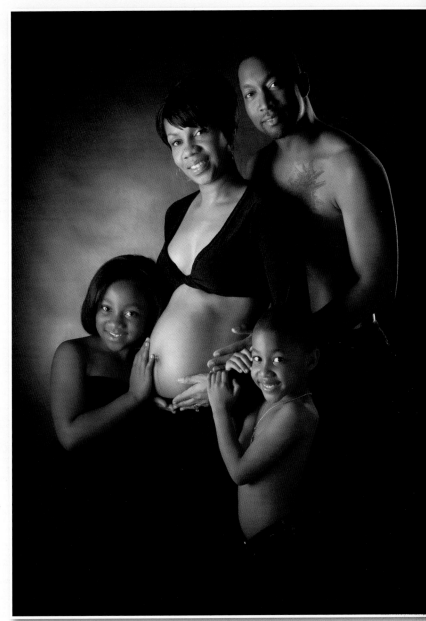

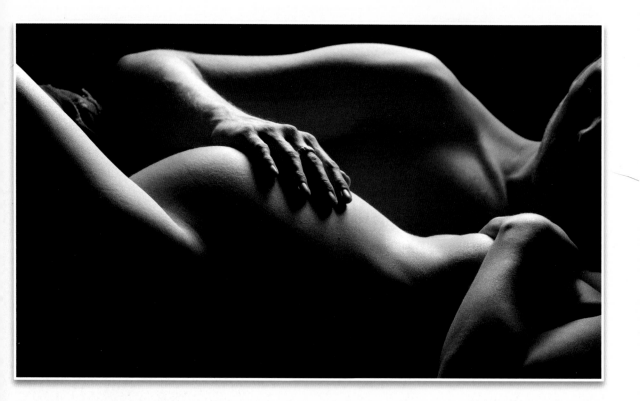

and tie them securely in the back. The nice thing about fabric wraps is that you can work around a client's pants without asking her to undress on the bottom at all. Male photographers find this a comfortable alternative to the all-nude session. To avoid using too many fabric clamps, secure the fabric with knots at the subject's lower back or hip and then roll the knots inside the waistline for a smooth, finished look. Then cascade and wrap the fabric however you like to create mesmerizing portraits that emphasize feminine beauty.

Regardless of the type of session clients seem to prefer in the pre-session consultation, I urge them to also try a fabric-wrap approach. I bring these wraps out after I have gotten what I can in a session, so the client feels that I did what she requested. At my studio, these fabric-wrap portraits are often the most popular and best-selling looks. If a client is hesitant, I ask her to trust me. I like to tell women that if the final result doesn't look good, I will not include the images in their slideshow. When they see that I understand their hesitation but feel confident that I can make them look amazing, they usually give it a try.

Once I had a client who had gained a significant amount of pregnancy weight. She really didn't seem enthusiastic about the maternity session at all—her husband wanted her to do it, because they had seen some of my work in a hospital display while taking a tour there. To the husband, his wife was as beautiful and glowing as ever. But in her eyes, she felt very unattractive and self-conscious. When she arrived for her session, she was wearing all black clothing. I felt a bit concerned about getting a good shot that I could be proud of. I tried to manipulate the lighting, but it was nearly impossible to show off her bump without showing off her weight gain as well. Being a woman, I could appreciate her instinct to cover problem areas, and as a mother of four, I could appreciate the frustration and discomfort of pregnancy. So I spent quite some time talking with her before she allowed me to do a fabric wrap. I used some light-colored tulle and convinced her to show off her belly for a few shots. I offered a bean bag for her to recline on, which provided plenty of support while enveloping her curves and slimming down her arms and hips. This is a great technique; you can use any fabric you want to drape over the bag to create the desired look. By carefully positioning her arms, angling her

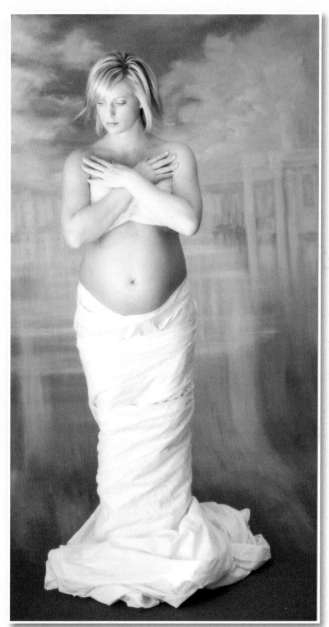

torso, and arranging her hair in a certain way, she looked like a goddess. It took me a while to get that shot, but I was determined to get it, especially after convincing her she would love it. At her sales meeting, I saved that image for the very last. When she saw it, her eyes widened and then filled with tears. Her husband let out a gasp, and I knew in that moment that I had succeeded. I had given them a portrait that they couldn't have even imagined, and I had given that woman a beautiful image that made her feel amazing about herself. This is a memorable reminder of how a little nudging can really go a long way for you and for your maternity clients.

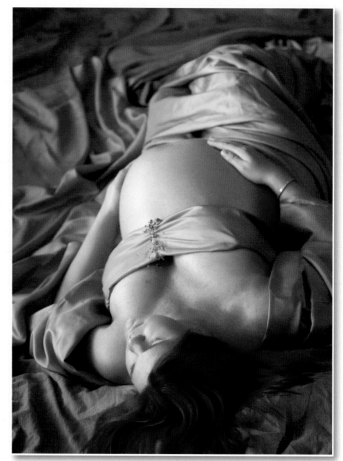

During a pre-session consultation, encourage your client to bring the following items for an amazing session:

◈ Nude shade panties and bra. If the client has a strapless bra, even better.

◈ Pre-pregnancy jeans that she can pull up to her hips. You aren't going to zip them, but they do a beautiful job of showcasing a round belly. They also work better than maternity jeans, because you don't have to conceal the cloth panel. Yoga pants are a great alternative.

◈ A pretty sports bra. This can conceal the top if Mom is self-conscious but still give a full view of the tummy.

◈ Pregnancy blouses or dresses that are snug fitting on top and do not flow out until after the bust line. Again, this style gives definition to the belly.

◈ Anything that would be special to include in this moment. I have seen teddy bears that had belonged to Daddy, tiny shoes, or a special blanket that is sitting in the nursery waiting for the new arrival. I also have clients who will bring Dad's leather jacket to wear or a very sexy pair of high heels. One expectant mother was a firefighter, so I photographed her in her helmet and yellow slicker for some very dramatic images.

Makeup should be done as if Mom is going out for the evening, and I recommend keeping the hair simple. Make sure those nails look fabulous.

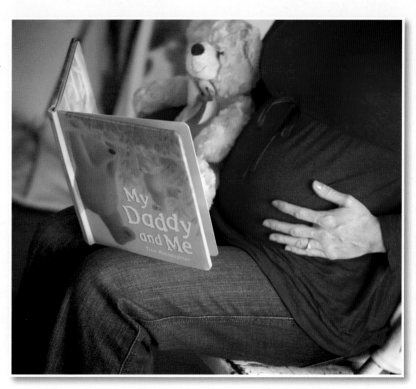

Accessories should be simple, because the belly is the focus of the images. The most popular jewelry item that I recommend for clients is their wedding rings if they are still able to wear them.

Regardless of the session style, most of the poses are very similar. Some of my favorites are just the body standing, with one hand poised at the top of the belly and one hand resting on the lower edge of belly, almost on the hip, with the arm and elbow extended away from the body. This can be quite sophisticated and flattering for most body types. Just remember: the belly goes away from the light, while the face points toward it. This pose helps minimize the problem areas and highlight the belly and face. One knee pointed across the body can help create that ever-flattering S-curve and soften any pose instantly.

Another good maternity pose is to drape one arm over the breasts with the other poised in the air over the head. Dad's and Mom's hands making a heart over the belly is another popular choice.

My least-favorite maternity pose, but one that I see a lot of photographers shoot, is the body pointed straight at the camera, with both arms crossed over the breasts. It's very unnatural and far from flattering. There are times to break this rule, but in general this is one pose you want to skip.

93

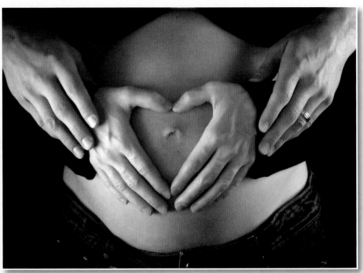

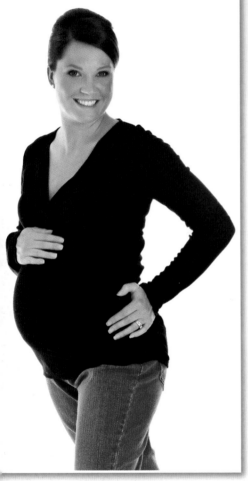

You can use a bean bag or pillows to create stunning shots of your client resting in thoughtful contemplation. These look amazing with nude sessions and fabric wraps but are a bit unnatural with fully clothed clients.

Using a ladder allows you to create unique angles and perspectives, but you must constantly remind your subject to arch her back, lean back, stick her chin out (to eliminate any second chins), and look into the light. These little tweaks can make a world of difference in your images.

The truth about maternity sessions is that you don't need as many poses as you do for baby sessions, because it is less likely that your clients are looking for collages or other products of that nature. Most of my maternity clients want one large, framed portrait for their homes and perhaps a small album. So it's worthwhile to put a little more effort into making one image truly amazing. That said, it's also a good idea to create some sample collages or storyboards for your clients to see during their pre-session consultations and increase your sales a bit by incorporating more images into the order.

However, as I mentioned before, the most important aspect of a maternity session is its potential to lead into a baby program purchase. That first year is where the magic really happens and where the bigger picture comes together in terms of future purchases and client loyalty.

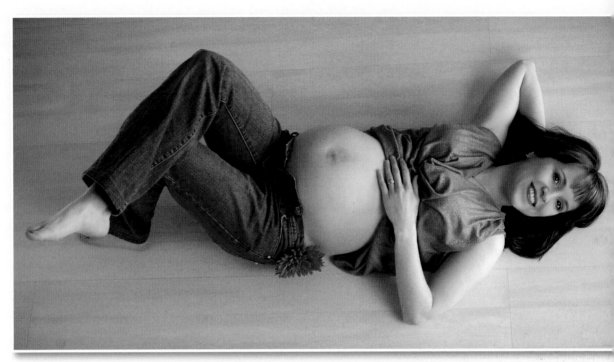

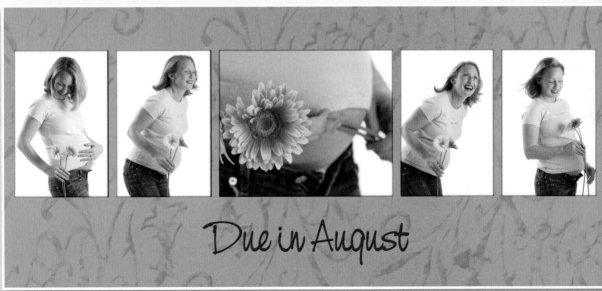

Due in August

Chapter Eight

Becoming a Baby Expert

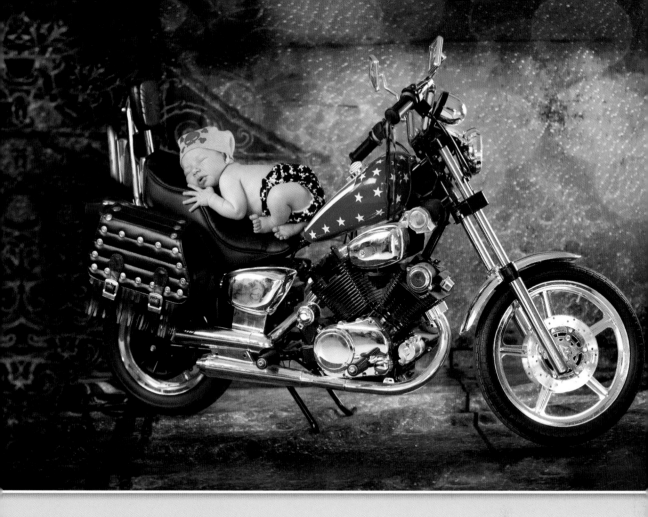

Before discussing the three-month session, I want to touch on a few key points that you should incorporate into any baby session to get successful results time and time again.

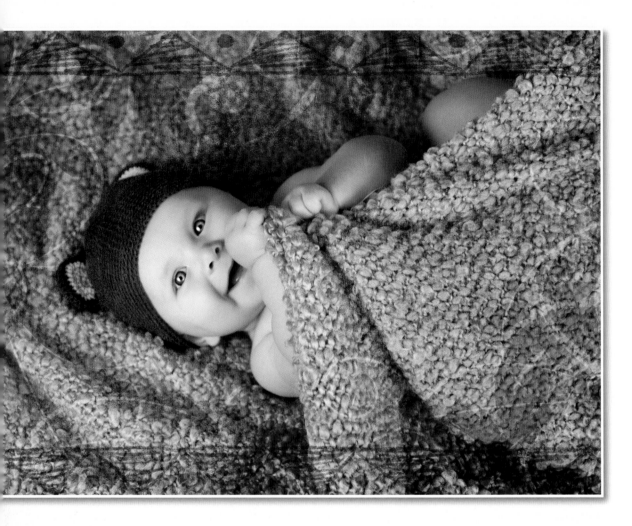

First, some dos. Do relax, breathe, and have fun. Make each session fun and carefree. Most new parents are going to be a bit nervous and intent on getting those perfect shots while at the same time being concerned for their baby's comfort and well-being. It's important to instill a sense of professionalism so your clients feel confident in you and your ability to work with their child, be it a newborn or a one-year-old. If the parents are relaxed and enjoying the process, the baby is sure to pick up that vibe, too.

Now for the don'ts. Do not force anything. If a pose isn't working, you might have to alter it to make the parent or baby more comfortable, or just skip it altogether. If a client is intent on capturing a certain pose in the session, do your best to accommodate this desire. Acknowledge the request first and foremost and assure the client that you will do everything you can to get that image, but you want to also be sure to get some other ones that are less difficult for you and for the baby.

Also, never stress out. As mentioned before, losing your cool only stresses out the parents and then the baby. It's one big mess. Do whatever you need to stay calm, patient, and pleasant. A good sense of humor can work wonders in stressful situations. Look for jokes in the moment and show your clients that you know what you are doing and can work with any situation. Above all, don't give up. There is very rarely an occasion where you won't be able to get the shot you need—if not several good ones. You just need to be patient, but good results can come from even the most impossible of sessions.

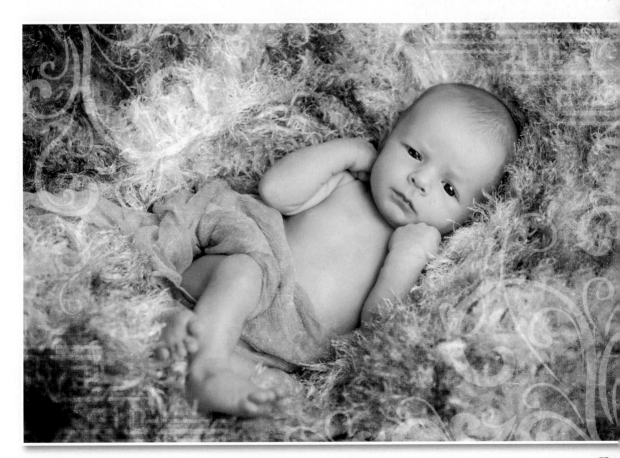

Beyond the basic dos and don'ts, mastering other essential tips will turn you into a baby expert. If you incorporate them into your sessions consistently, they will become second nature in no time. For instance, with a crying baby, you may need to simply take a ten-minute break to let the baby calm down. Let the mother feed, diaper, and otherwise comfort the baby before you try to continue the session. Don't rush things along—just relax and let it happen. Babies are not known to cry for hours on end, so you need to trust that if the energy level is good, the room is warm, and the baby's needs are met, in a matter of time the baby will settle down, and the session will progress. With any luck, a crying bout will lead to a more fatigued and relaxed baby twenty minutes down the road.

That brings me to the sleeping baby. Although I am not photographing actual sleeping babies in many of my "miracle shots," there are times when a baby has genuinely gone to sleep during a session.

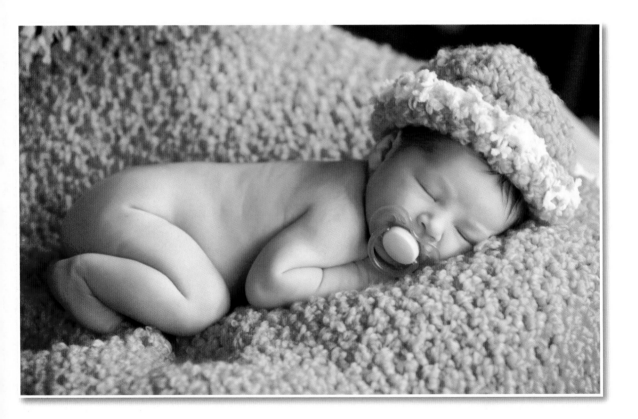

To keep the baby settled, I use these moments to do a few creative shots or simply continue the session as quietly and gently as possible, depending on the scenario. Whatever you do, if the baby falls asleep while sucking on a pacifier, be careful about when and how you remove it. Even after a baby has stopped sucking, the pacifier is still suctioned into the mouth very tightly. If you simply pull it out, the motion and the popping of that seal will wake the baby right up and probably alarm or upset the infant too. Instead, when you're sure the baby is relaxed, ask the parents whether you can remove the pacifier. Because typically the parents prefer to do it, instruct one to stick a finger in the side of the baby's mouth to break the seal and then slowly remove the pacifier once the suction has been released.

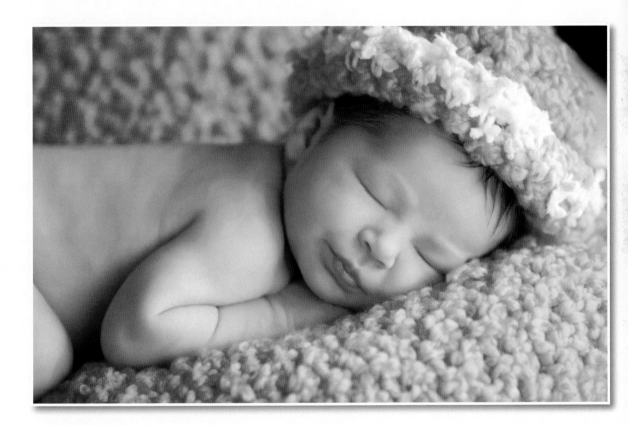

Although a sleeping baby can provide the best opportunity for some "miracle shots," be sure you're satisfied with the session overall before you take a chance on them. It's important that you don't display too many amazing sleeping baby portraits in your lobby, because parents will fall in love with them and come to expect that particular shot. As with any situation in life, particularly business ones, it is best to underpromise and over-deliver rather than the other way around. Try to display breathtaking samples of the five poses or other images that you can easily re-create and only incorporate miracle shots into marketing materials. This way, when you present your clients with miracle shots, they will be overwhelmed and completely overjoyed every time. You don't want them to see it coming.

Now for some quick posing tips. When it comes to shoes, I never encourage clients to have the baby wear them. They make the feet look enormous, and, frankly, the feet are one of the most adorable focal points. It's a shame to cover them.

When parents want their babies to wear shoes and bulky clothing, I always humor them first by taking a few images and then ask them to remove the clothing items, because, in my experience,

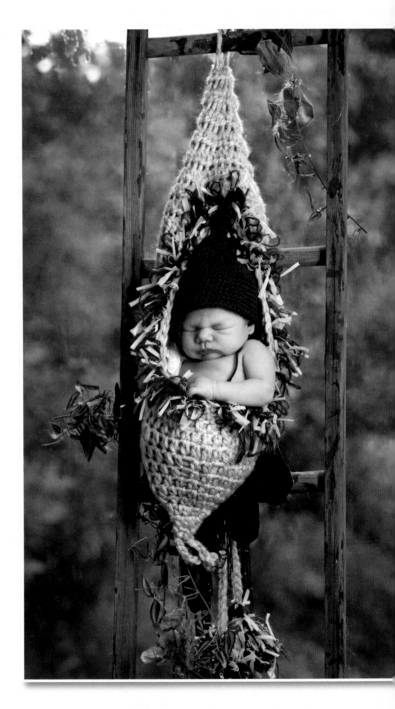

102

it's worth taking a few shots to show that you value their vision and preferences while knowing what looks best and what really sells. I also insist on long-sleeve shirts for parents. It's best to keep several sizes for women and men in your studio (black, of course) in case a client shows up unprepared. Short or three-quarter-length sleeves can be very distracting and unflattering.

Next, if a client brings in a prop that is meaningful, *use it* and use it first. These items are most likely to have been specially purchased or received from a family member, so you want the baby to be fresh and cheerful for them. You also don't want to overlook that prop and then try to squeeze it in at the last minute when the baby is tired and fussy.

With these tips, you can become a baby expert in no time. Practice them without fail, and you will be amazed at how your session experiences and results improve.

Chapter Nine

Newborn Sessions

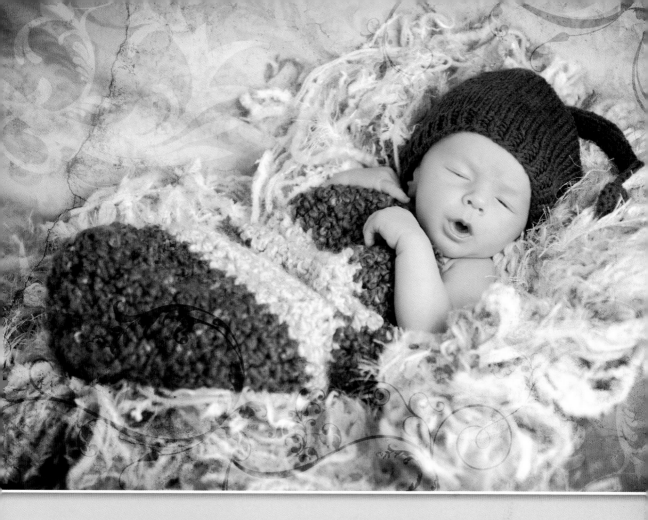

Once you have a new baby plan client, the first session is by far your biggest opportunity to impress and your biggest opportunity to sell. There is no time when new parents are more emotional, excited, and sentimental about their newest addition. My preference is to photograph the baby as soon as possible, ideally within the first five to ten days after birth. Although this session is the most important, be warned—it can also be the most difficult to create, as the baby is very new, the parents might be inexperienced themselves, and you will only have so much time to capture all the shots that you need. But with a simple equation, you can make every newborn session magical for your clients and for your bottom line.

105

5 + 20 = Success

Just remember: five poses in 20 minutes. If you master this concept, you'll have all the tools you need for a successful newborn session. This chapter ensures that you understand the five poses so that with practice, you can create an amazing series with little to no stress.

I talked about the pre-session consultation in an earlier chapter, but for a newborn session, it is important to also touch on key points to help new parents relax. For this photography session, I recommend long sleeves and solid colors, preferably black, for Mom and Dad. I also recommend a higher neckline, so that when baby is being held to Mom's chest, the only skin visible is baby's. Jeans or dark pants are perfect for the lower half.

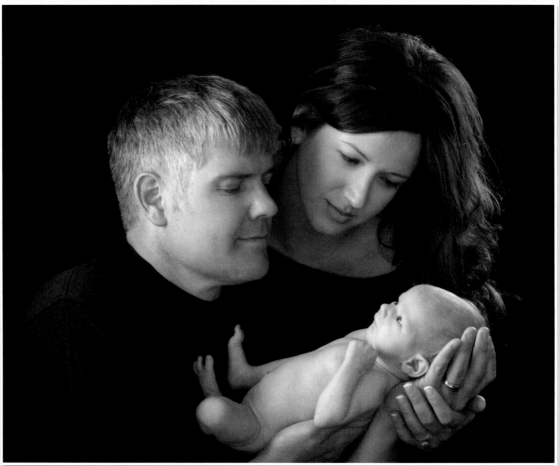

For skin-on-skin images (my favorites), I recommend that Mom wear a black tube top or camisole with straps that can be easily slid off the shoulders and tucked into the top, because I will be focusing on holding the baby closer to her face and shoulders. Makeup should be styled as if Mom is going out for the evening, but keep any jewelry very simple and minimal. The wedding ring and stud earrings are the only jewelry I recommend for these sessions, because anything else just detracts from baby. Hands are prominent in these images, so I encourage Mom to take some time out for herself beforehand to get a simple manicure.

Baby is going to need to feed during the session, so make sure the clients bring whatever they need to take care of this. They should bring several extra diapers, a pacifier, and possibly a change of clothes for themselves. I also often tell clients, "Your baby is going to take an unannounced bathroom break, probably while being held in the most tender of poses. It happens almost 100 percent of the time, and my staff is prepared for it." You would be amazed how this one piece of information calms down the

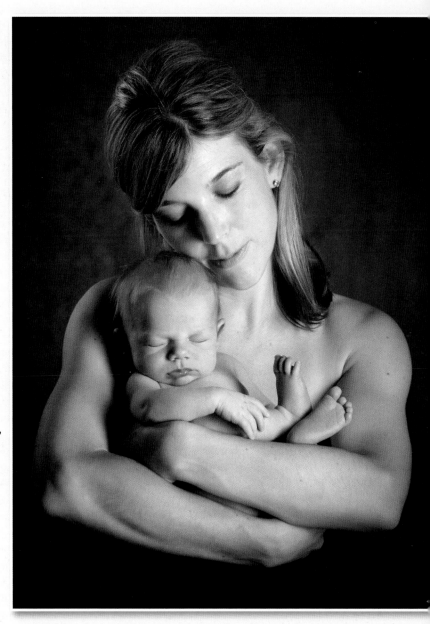

newest of moms! You should also remind clients to arrive at least 15 minutes early so that they can relax and settle in before their session begins.

Once you have a new family in the studio, it is a good idea to highlight a few posing tips so they are prepared to follow your instructions. Before I get started with anything else, I discuss these five points to ensure that the parents understand what they mean:

◈ Posture is everything. When holding a baby, people naturally curve their backs. Good posture is critical, because a curved back makes the subject look heavier than he or she really is. I often say, "Sit up!" because when clients do so, they look more slender.

◈ Keep thumbs near fingers. When holding a baby, people often separate their thumbs from their fingers, but this makes it look as though they are roughly gripping the baby. If I mention "thumbs in," it just means to bring them near the rest of the fingers without hiding them.

◈ If the baby starts to pee or poop, don't freak out! Instruct parents to hold the baby away from their bodies and let the mess hit the floor. I assure my clients that I have all kinds of cleaning supplies for the floor, but if they get all wet, the baby will not want to be held.

◈ Make a chicken neck. This direction sounds silly, but if I say, "Chicken neck," I want Mom to extend her neck out (like a chicken in the yard). Most women carry weight in their faces and necks after they give birth, so extending the neck visually eliminates that weight.

◈ Use soft lips. If I want parents to kiss the baby, I say, "Soft lips." This doesn't mean to pucker up; rather, they should just hold baby close, with their lips near the head or cheek. Puckering creates wrinkles around the mouth, so a soft kiss is more flattering.

These simple considerations help newborn sessions run smoothly, quickly, and successfully.

The Sandy Puc' Five Poses in 20 Minutes Series

Many years ago, I created this formula as a surefire way to instruct photographers on how to create a simple, saleable session in a timely fashion. Over the years, it has been used all over the world, and I still smile when people thank me for creating it.

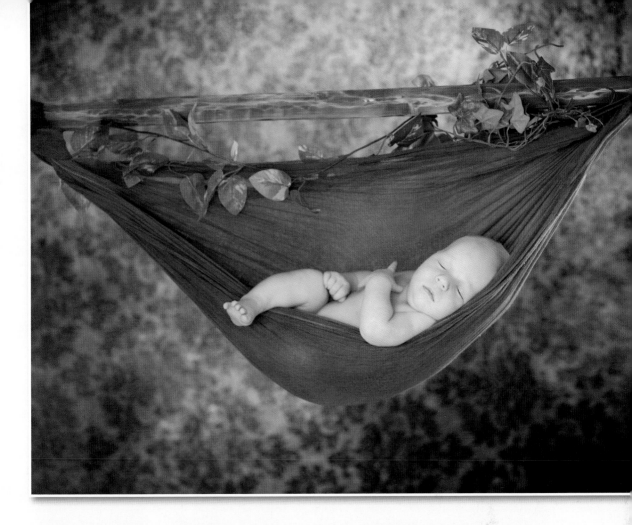

The five poses have been designed to be done in a sequence, and they can easily fit into the first 20 minutes of a newborn session. Most of the poses are also created to avoid reminding the baby of nursing, but if the baby needs to stop for a break, that is fine. Full babies can create messes, but they are always more content. Don't rush too much, but be aware that until you capture all five poses, you're not done with the bulk of the session. With practice, you will get better at cruising through these poses and getting these staple shots out of the way so that if you run out of time or the baby runs out of patience, you still have sellable session images. Then if you have extra time, you can capture a few "miracle shots," such as the sleeping baby.

Pose #1

The first pose is "the nest." This is a great pose, because it hides the problem areas on Mom while demonstrating the intimate bond beautifully. The baby's cheek is positioned near the parent's chin, with the arms cradling the body and the legs facing out. This pose is an easy way to show the relationship between mom and baby, and it also helps hide the private parts as well. Typically, each pose has three to five variations. In this pose, I take one horizontal three-quarters pose and then continue to zoom in until the last shot is a close-up of Mom's and baby's faces. You can create a lot of variety without even moving your subjects.

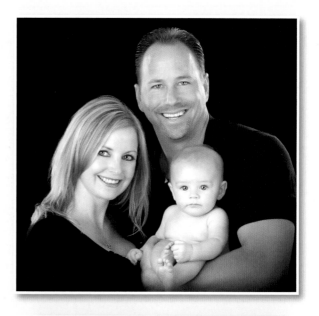

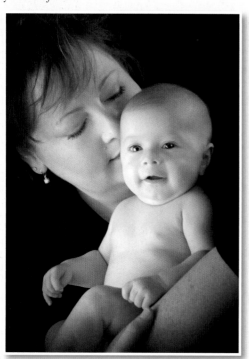

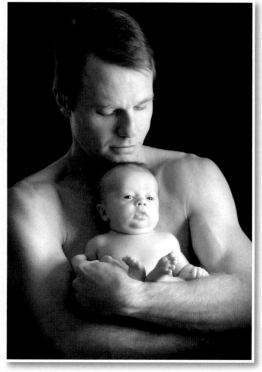

Pose #2

Next is "the cradle." This pose features a sweet, eye-to-eye shot and is a best-seller. The pose can work beautifully for a father or mother. The baby is held facing the parent, with the feet tucked under the parent's chin. For mothers, the neck area can be a bit heavy, so this is a good pose to remind them to stick their necks out. You can vary the eyes, with a few shots looking at the camera and down, and then have the parent drop his or her lips to the baby's head, eyes downcast. These images are truly beautiful. Again, remember to shoot for variety by starting wide and then zooming in to maximize the choices without moving the subject.

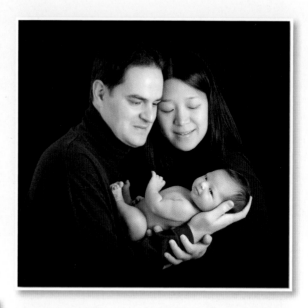

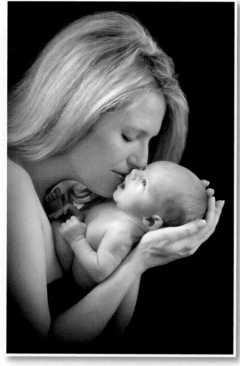

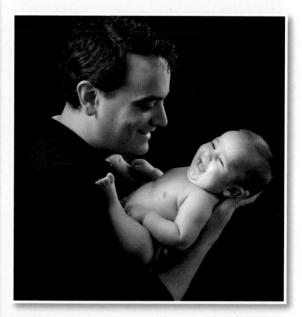

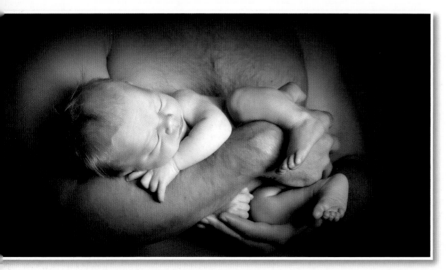

Pose #3

The "football hold" is next, which brings the baby closer to Mom and often cheers the infant up a bit. The baby is cradled in one arm, with the other hand underneath gently pushing up toward the collarbone to give a little lift and support. Newborns have very little neck strength, so their little faces will get scrunched without that hidden hand offering support underneath. Have the parent hold the baby at chest level for the first three or four shots (horizontal and vertical), and then have the parent hold the baby up and slightly out from the body to avoid shrugged shoulders. Once again, end with the lips held to the baby's head and eyes cast down. This can be a harder pose to master, so practicing with a baby doll to perfect the pose and lighting before a real subject is there is highly recommended.

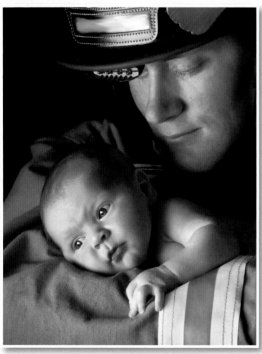

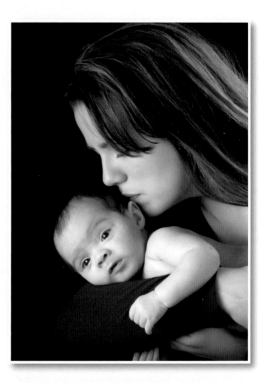

Pose #4

The fourth pose is called "chest to chest." After the first three poses, the baby sometimes starts to get frustrated, so this position is calming and very natural. Ask Mom to hold the baby in a burping position, and with a few tweaks the baby is comfortable, and Mom can relax. This is a wonderful pose for mothers, as it highlights their connection to the baby as well as their beauty and strength. (It also shows off cute baby bums!) With the baby facing away, the mother becomes the focal point, creating a powerful image. I find that at this point in the session, this pose is a wonderful way to calm the baby down, even allowing the use of a pacifier as the baby is facing away. After you get a few shots of Mom, remove the pacifier and zoom in on the baby's face once he or she calms down.

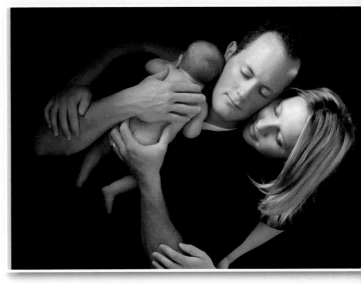

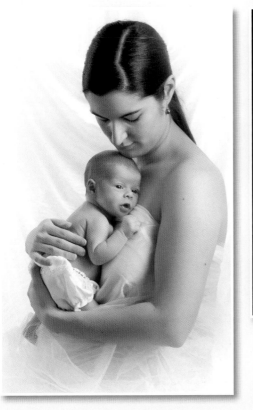

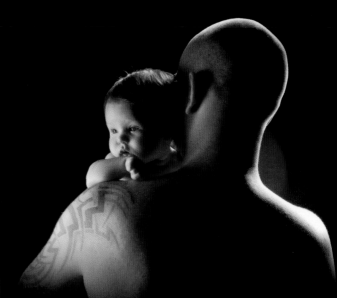

113

Pose #5

Finally, the fifth pose is the "baby tilt." This elongates Mom's neck and eliminates double chins while creating unique angles. This pose is similar to pose #2 (the cradle), but it's shot from a ladder for variety. The ladder not only creates a new angle but, more importantly, forces Mom to look up, so any extra weight in the face and body falls away.

During the last pose, I try to capture a few important elements for the final sale. Images of those baby toes and fingers and, of course, a tight face shot are a must. Even if the baby has had it, you can have Mom comfort or nurse the baby for this final series. Manipulate your lights to get more shadows in the hand and foot shots, because they add so much more drama and interest. Let each crevice and dimple show. There is beauty in those details.

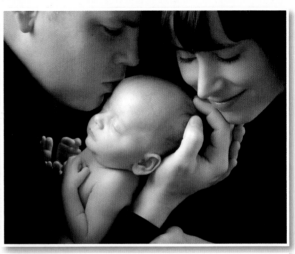

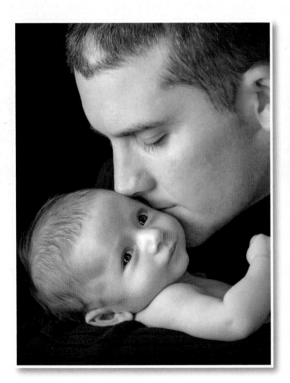

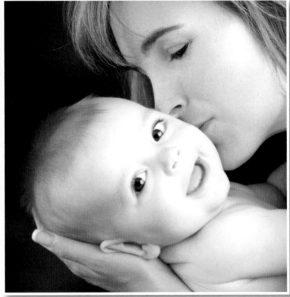

Working with Multiples

Now it's important to touch on those sessions where you are working with multiples. You need more time for these sessions, so expect that when you book. I usually schedule a double session for

multiples—anything more is exhausting for me and for Mom. All five poses work well with multiples, but they do require more patience (this above anything else!), time, and assistance, be it from family members or your staff. I charge for a separate baby plan for each child, whether it is a set of twins or triplets, but the client gets individual and group portraits during the sessions. Regardless of the number of babies involved, stay on track with the five poses to create the most diversity in your session and the best final products that you can.

Once you get these five poses, you can offer your clients a full range of wall art, collages, albums, and birth announcements. You will have such a wealth of amazing images to choose from that you are sure to sell plenty of portraits and products from this initial newborn session.

Do not restrict yourself only to these five poses, though. The goal is to capture them in the first 20 to 30 minutes, leaving the remaining 30 minutes for what I call "miracle shots"—the shots of babies sleeping in baskets, on chairs, swaddled in cloth, or hanging from a hammock. These images are much more time consuming to create, and if the baby gets frustrated, you may wind up without any usable shots. This is why I always shoot the five poses first. If the baby gets upset, I know that I still have a great series of images for the client to enjoy. Of course, the miracle shots are the showstoppers, so capturing them is always my goal when I begin a session. The baby ultimately decides what I get, but being prepared and efficient helps me get the job done.

Chapter Ten

Three-Month Session

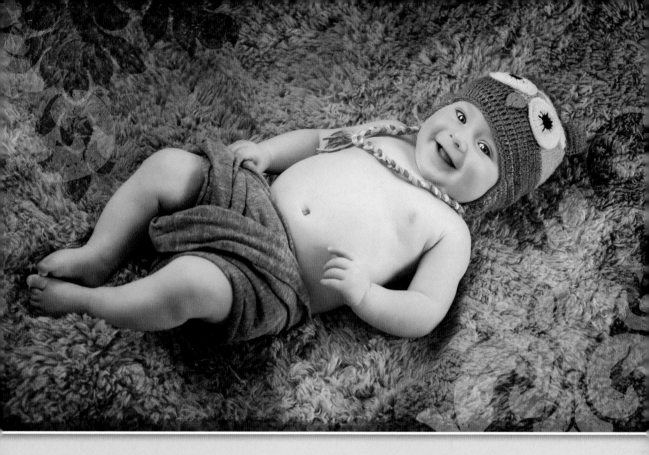

This phase of a baby's first year is full of new milestones and lots of cute, wiggly smiles. Most infants can pick up their heads on their own, but you may need to wait until age four months to let the baby's neck strength increase. The tummy shot is the crown jewel of the three-month session, so you really want to get the baby at a point where he or she can pose with his or her head held up comfortably.

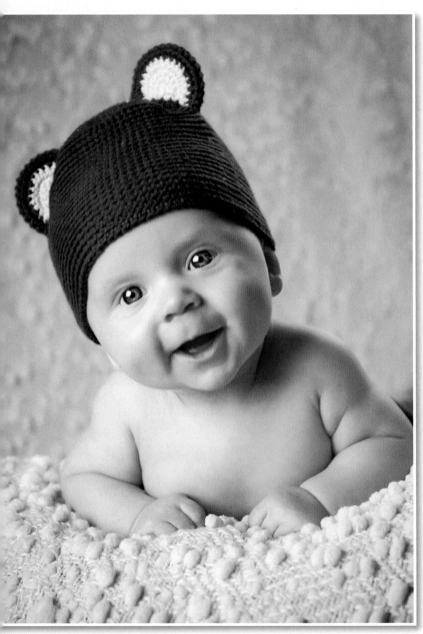

As far as sets go, you really don't need a big space for these sessions. The baby is not very mobile yet, so the session is basically going to revolve around a pillow covered with some kind of cloth or blanket and a nice background. As I mentioned previously, Westcott Backgrounds and Silverlake make wonderful designs and high-quality products that I love to use. For posing pillows, Wicker by Design makes a wonderful option that is adjustable for any size baby. You can even opt for a waterproof option for easy cleanup after accidents.

Another consideration for the session, because there isn't much interaction or movement yet, is a cute hat, scarf, or other accessory for the baby. I find many of the cute items in my studio on such sites as Etsy.com.

You should have between four and eight different accessories for your clients to choose from before a session. It's likely that you will only end up using their favorite three looks. You don't want to give them too many options and overwhelm them, but it's always wise to give clients plenty of variety to make sure there is something they truly can't live without in that sales meeting slideshow.

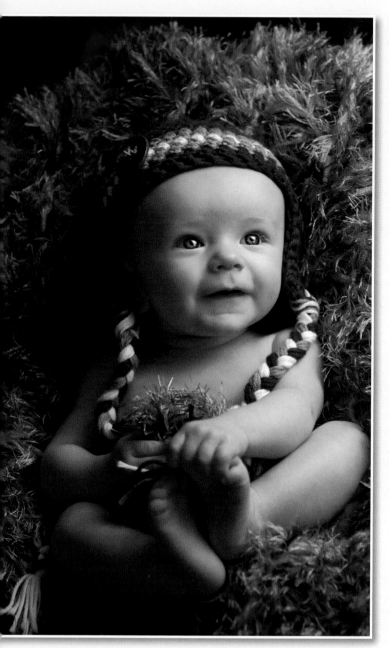

With three- and four-month-olds, it can be very difficult to get their arms and legs into the proper positions. Babies like to keep their limbs stick straight instead of curved and chubby looking. It's best to be patient with babies and distract them with props, such as a rubber chicken or a shimmery pompom, while gently shaking their legs or arms into a relaxed position. It can take time to achieve, but that natural pose looks ten times better than their jutted-out limbs do.

Your voice is a powerful tool in keeping the baby's attention focused on you instead of the nearby mother. A soft, gentle, bubbly voice with higher pitches mixed in can work wonders. The higher the pitch, the more intent a baby will be on the voice. Keep your tone gentle but stimulating. Such phrases as "Who's the queen of the world? *You* are!" or "Who's a *big* boy?" are some of my favorites. You can also clap in a slow, rhythmic pattern to calm babies down and direct their attention toward the camera. Babies love sound patterns immensely. If a baby is getting really wiggly and overstimulated, simply slow your voice way down and lower the pitch. You can direct the baby's mood with your voice and your energy in amazing ways.

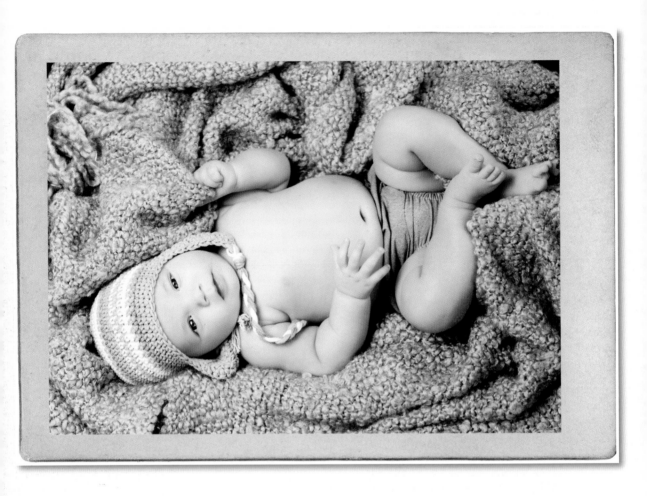

Throughout the session, keep the room warm and allow breaks as needed to change, feed, and comfort the baby. These steps help the session move forward slowly but more enjoyably for all.

Start the session with the baby posing on his or her back and then lying on his or her tummy, followed by some detailed shots of the hands, feet, eyelashes, dimples, and so forth. Once those are done, you can try to get a few creative shots.

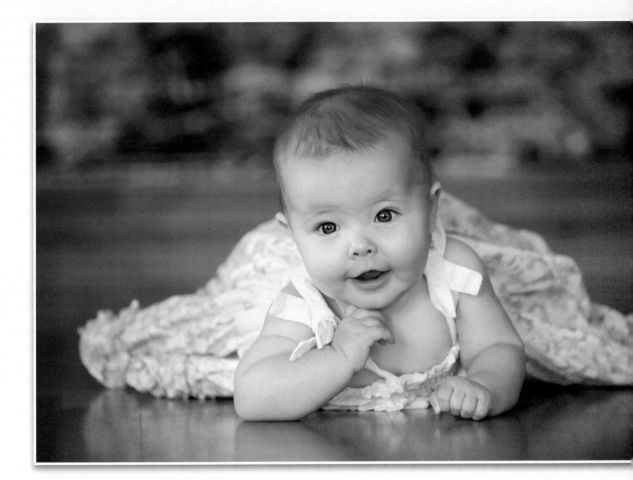

Your lighting for those two main poses should be standard, with the light going where the eyes go. You may need to adjust the light to keep that standard, but it is absolutely essential. Remember to clap or use props to redirect a baby's face into the light. If the baby is transfixed with Mom, you can also block the baby's face with your hand for a few seconds until he or she looks away. Mom can also look the other direction while staying nearby to discourage the baby from staring at her. When you are ready to do the detail shots for the hands, feet, and face collage, shoot on the shadow side to get more definition. Those macro shots are really important to the product line for this session.

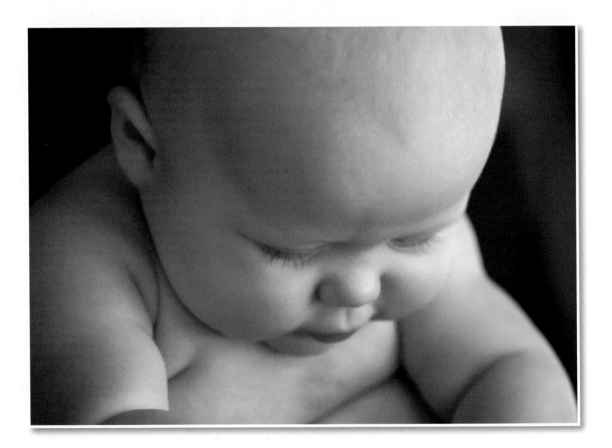

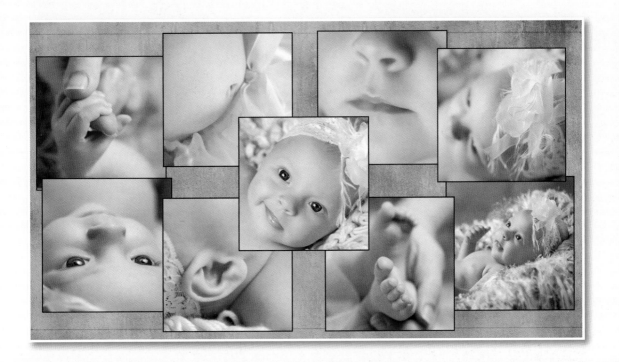

If this is the first session a client has with you, shoot for birth announcements as well as wall art. Many clients want several 5×7 or 8×10 portraits for grandparents and other family along with a brag book containing several of their favorites. By the final one-year session, an album capturing the entire first year might be ordered with images from each session, so as I mentioned before, be sure to keep your lighting consistent so that you don't have extra work in Photoshop later on.

As you prepare for the sales meeting, include a few product samples in your slideshow, if possible. ProSelect is a great program that allows you to incorporate custom slides and a calming soundtrack.

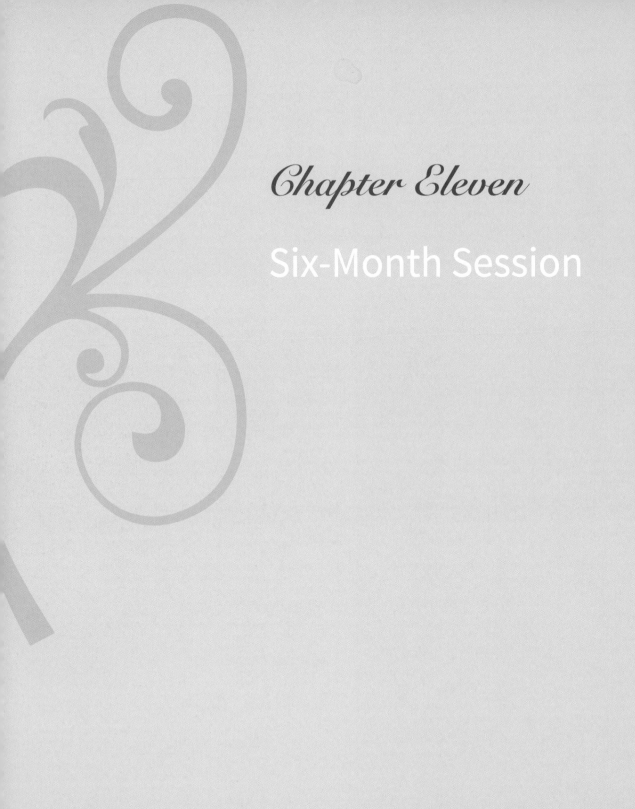

Chapter Eleven

Six-Month Session

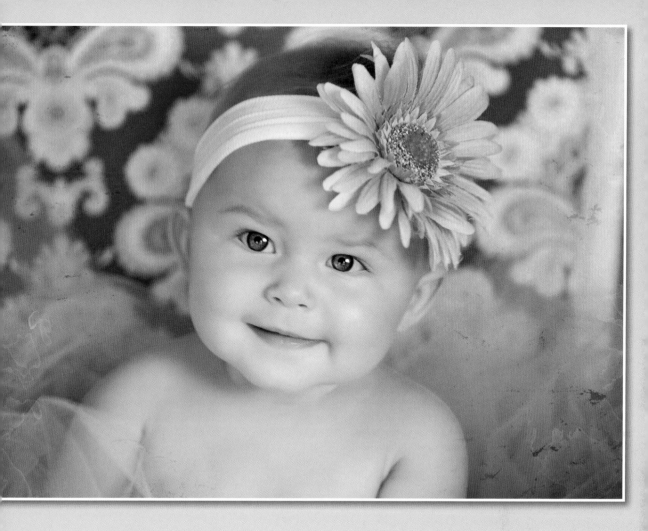

The physical milestone for the baby's six-month session is to sit up without much assistance from Mom. This phase of the baby's development lets you capture lots of fun poses with a variety of props. For less-developed babies, a box or basket offers added support, while a colorful chair is great for more-developed babies who can sit on their own and perhaps even stand with assistance.

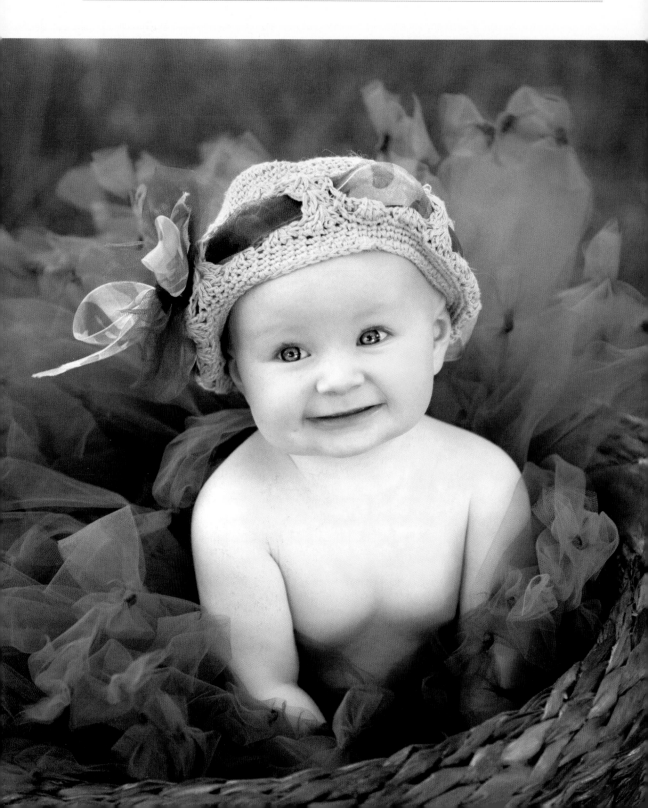

If the baby seems somewhere in between, it is best to simply pose him or her right on the floor for most of the session. Babies at this age are still fairly wobbly and unpredictable. In any case, be sure to keep Mom close by at all times, just out of the shot. Make sure she understands that she may reach out and catch the baby at any time and not worry about waiting for the shot. Safety is always paramount, and quality portraits come with a little patience. For most of these poses, I shoot with

a longer lens from far away and then compress, but I don't recommend this technique for newer photographers. If you are just starting out, it helps to be closer to your subjects, but try different approaches to see what works best for you.

The main way to direct a baby's focus is still with noises and props, so try to keep the area you are shooting in as calm as possible. The more outside activity, motion, and sound there is, the more you will have to compete for the baby's attention. For this session, I use a rubber chicken, a shimmery pompom, and a feather duster "tickler" as well as plenty of silly sounds. I trill my tongue, say, "Ahh . . . *choo*!" and clap my hands, among the other techniques I use for the three-month session. I still keep my voice low and gentle to keep the baby from getting overstimulated, never loud and shrill.

Sets can either be fairly basic or more creative, depending on your situation and the client's tastes and preferences. For girls at this age, a vivid tutu paired with a coordinating flower headband is always great, as is a simple dress. Add colorful accessories, such as long beaded necklaces or flowers. Boys look great in diaper covers, overalls, or shorts. In most cases, I think babies look best with no shirt or shoes on to

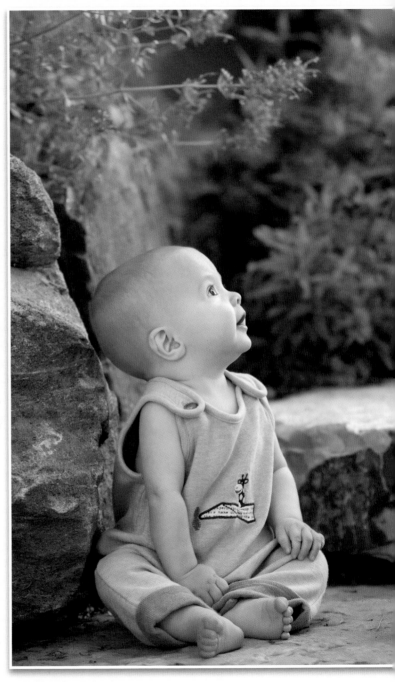

better showcase all their adorable dimples and rolls. You won't usually see complete outfits until that one-year session. Regardless of the gender, age, or time of year, beanies or hats are always adorable wardrobe choices. Parents love them, and the right color accessory can enhance a baby's eyes beautifully. Try to have as many color options as you can, keeping in mind that by six months, a baby's head is too big for a newborn's hat but will be swimming in a toddler's hat.

I like to use faux wood floors with a variety of background options for these sessions. As with the three-month session, have a few options already out to give your clients plenty of different looks to choose from. Fabric can make a great background, but keep in mind that any folds and wrinkles are distracting and take quite a bit of time to edit out using Photoshop. A hand-held steamer helps keep the wrinkles to a minimum, but in a pinch, get in the habit of rolling fabrics up and storing them in a bag. This creates a unique wrinkle pattern that looks better than a uniform fold. In addition to making some of my favorite backgrounds, Silverlake also offers flooring and even baseboards that disassemble.

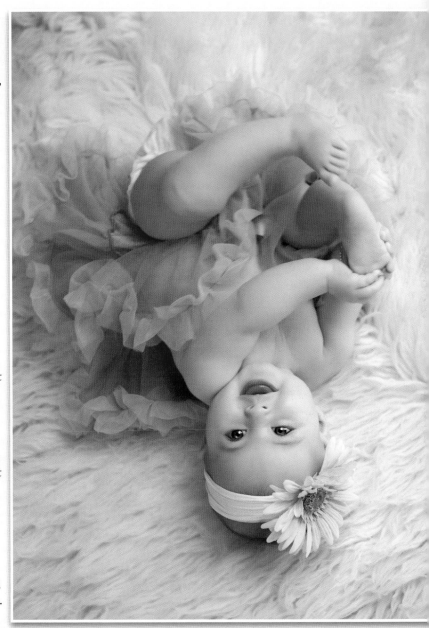

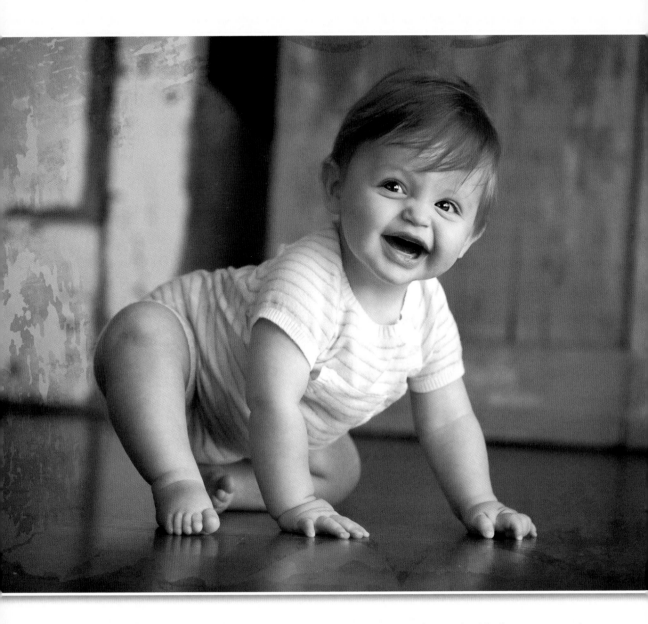

The sitting pose should come first, with the baby posed either in a box with a blanket, sitting on the floor, or sitting in a chair. Then you can pose the stronger babies standing on the chair while holding the chair back for support. Younger babies who aren't ready for this stage should not attempt this

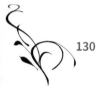

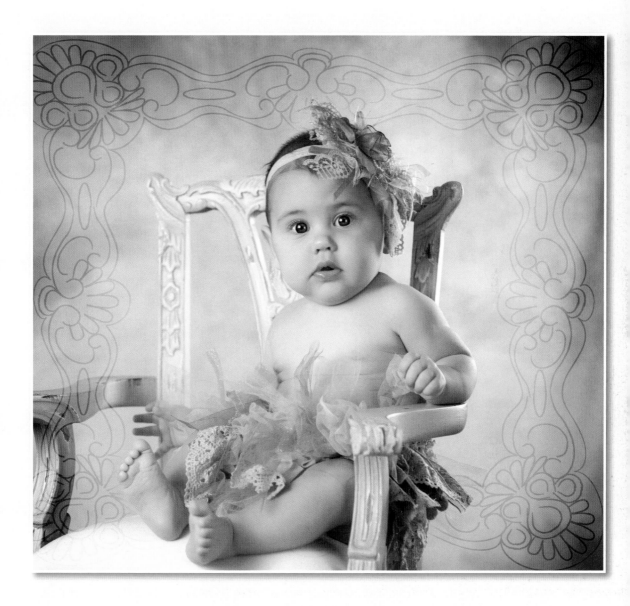

pose. Instead, switch to a fun tummy shot, rotated to the side a bit to show off how long the baby is getting. With each pose you do, try to incorporate plenty of different angles—some from high on a ladder or step stool, some low to the ground, and so forth. If you aren't using a tripod, stomp your feet rhythmically to get a baby's attention since your hands aren't free to clap.

You should also try to get a few different expressions. Get mostly smiles, but then say something like, "Uh oh!" in a deep voice, kind of slowly. The baby will look down and get serious for a few cute, pensive shots. The detail macro shots are still very popular for this session, as are series like the one shown. Use toys or other props to show a short storyboard of action, be it stacking blocks, clapping, or putting a hat on. Series can be featured in a framed collage, and a wider variety of shots looks great in what I call a 9-Up.

*Before you were **conceived** I wanted you.*
*Before you were **born** I loved you.*
*Before you were **here an hour** I would die for you.*
*This is the **miracle** of love.*

–Maureen Mansfield

9-Up collage

Most parents order a few 5×7 and 8×10 portraits for close family members and a framed portrait for their home. Suggest unique products, such as adorable Mommy Business Cards available from Ukandu.com, to keep your sales numbers where you want them to be for this session. You only have one more session to go at this point, and it is sure to be a best-seller.

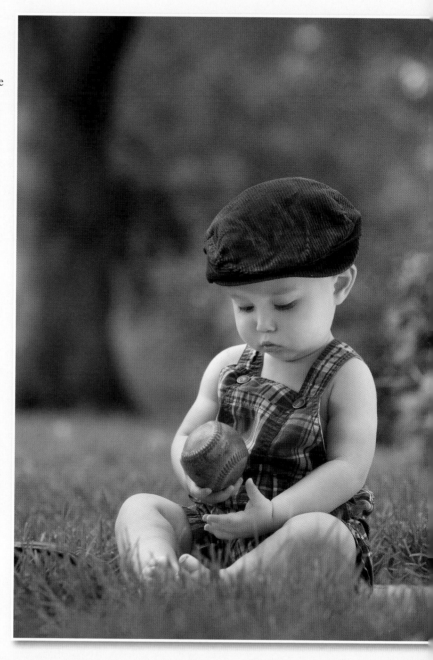

Chapter Twelve

One-Year Session

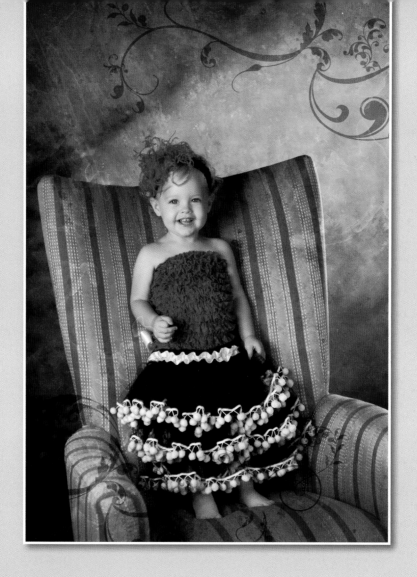

This is the final sequence in the baby plan, and as such it is very important to overdeliver in every way. You want your clients to leave this session and pick up their final order with a huge smile on their faces, guaranteeing that they will return as their children grow older.

This session captures a lot of milestones and yields a number of sellable products, so try to make extra time to get plenty of great images to work with. The earlier sessions have their own challenges, but this session brings new ones that can be very frustrating. Children at this age are very mobile. Most are walking if not running, climbing, and exhibiting a perpetual state of motion. Plan to adjust your camera for even quicker shutter speeds than normal. Studio strobes help a lot with capturing quick movements. For children with light skin and hair, you need less light. Darker complexions and hair colors look better with more light.

When working with studio strobes, I keep my setting simple. Typically my main light aperture is set at f/8 and my kicker and background light are at 5.6. My ISO is 100, and my shutter speed is 1/125. This "keep-it-simple" rule allows me to focus on the movement of the baby and not on creating difficult lighting patterns. There is a time and place for art, but a moving one-year-old offers plenty to focus on.

Another challenge for this session is the fact that one-year-olds are starting to become more aware of who is around them and therefore may have stranger anxiety in some cases. You need to take extra time with some

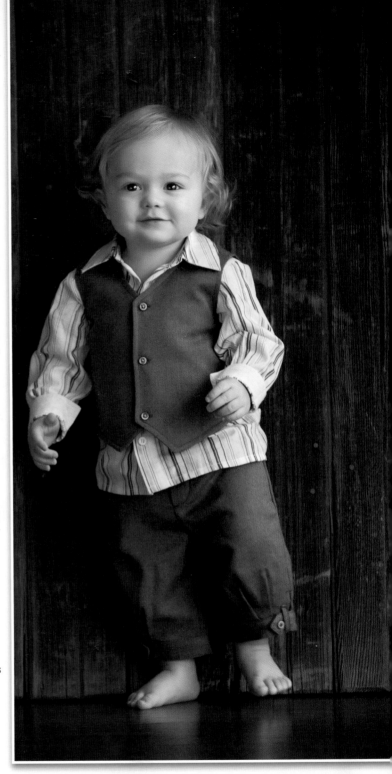

children to establish trust before you can get started with the session. Play catch with a ball, offer a treat or two, give high fives, and just hang out for a few minutes so that once the session is underway, you have built some rapport to get those smiles and poses you need. Interact with Mom or Dad as well. Usually if children can see that their parents are smiling and having fun, they will let their guard down and feel comfortable too.

Regardless of their individual temperaments, almost every one-year-old can completely understand you. It might not seem like it, but they are very alert and have a great grasp of the English language. So when you ask a baby to clap, stand, sit, or throw a ball, the child might not do it every time, but he or she does understand you perfectly. Encourage them to do things on their own, whether by asking, bribing, or distracting them. Try not to move babies at this age, because they will get mad. If it must be done, ask the parents to do it so they are the bad guys instead of you. (It seems unfair, but there it is.) If you take the time to observe the child's mood and personality, you can get amazing results by altering your approach based on what you see in the baby's body language, and especially his or her eyes.

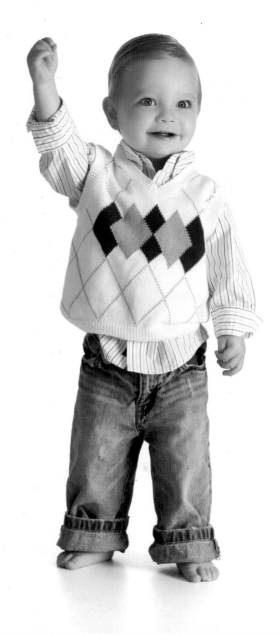

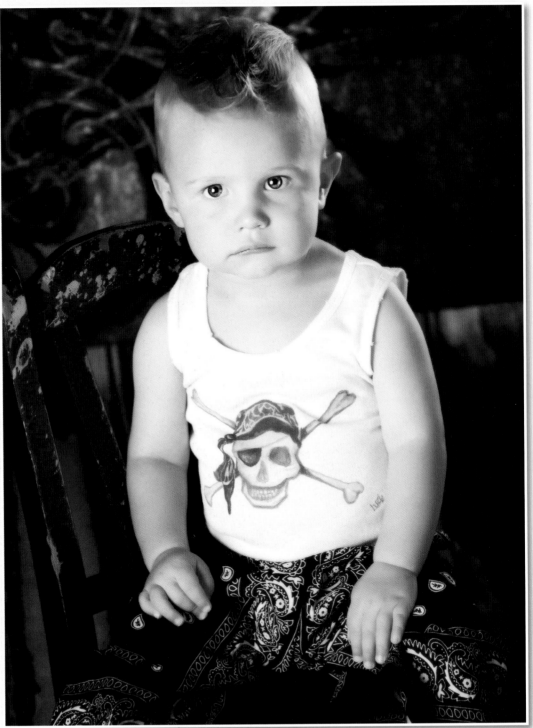

Eyes are the window to the soul, and young or old, you can always tell what a person is feeling when you take the time to examine his or her eye movement. It's not too scientific—as a human, you instantly relate when you zone in on any one person. We've all felt the whole gamut of emotion, and they are easy to recognize in others if you take the time. Some kids are really outgoing and thrilled with boisterous play. Shy kids may be completely freaked out by the photography experience, and even the best of intentions can ruin a session. On the other hand, a social child may be turned off if you are too subdued or indirect. Just take your cues from each subject and remember that this child is the star of the show! Celebrate and enhance the baby's personality, and you will have a bunch of sellable portraits in no time.

Remember to coach parents before the session about safety. They should always be just out of the shot but prepared to catch their little one should the child lunge forward or trip. But, as every parent realizes, you can't keep a child that age completely safe and scrape-free, no matter how hard you try. It just comes with the territory. Most twelve-month-olds have at least one scrape or bruise on their faces, and although that type of retouching is typically an add-on, you should include it for this type of session, especially if the accident occurs during the session. I always assure Mom and Dad that

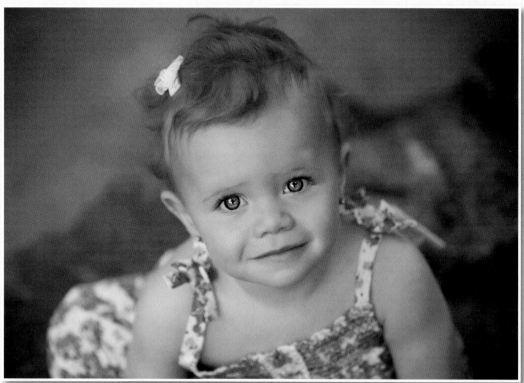

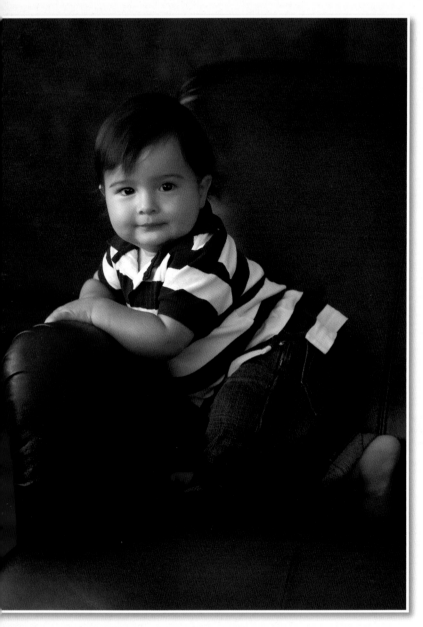

I will take care of editing these out of the final portraits, and they are relieved knowing that these owies won't be permanently documented or cost a fortune to remove. If a child does fall or get hurt, don't panic. Let the parent step in to provide comfort. Most of these incidents are very minor, and the baby calms down within a few minutes. The more frantic you act, the more frantic everyone else is too. Just stay calm and be patient.

The biggest milestone to capture for this session is the baby steps, which make a wonderful storyboard. Some babies still need support, and that is totally okay. You can pose them with a chair, bench, or other prop to give them a stable place to stand. Some of my favorite images are of a baby holding onto Mom's fingers while taking those steps, and all you see of the parent are legs, bare feet, and fingers.

Typically, I start with the least amount of clothing first and end with the most complicated outfit, as the changing process can really upset toddlers. If you get some great shots under your belt, it's less important if the baby becomes irritable after being dressed in a more elaborate getup.

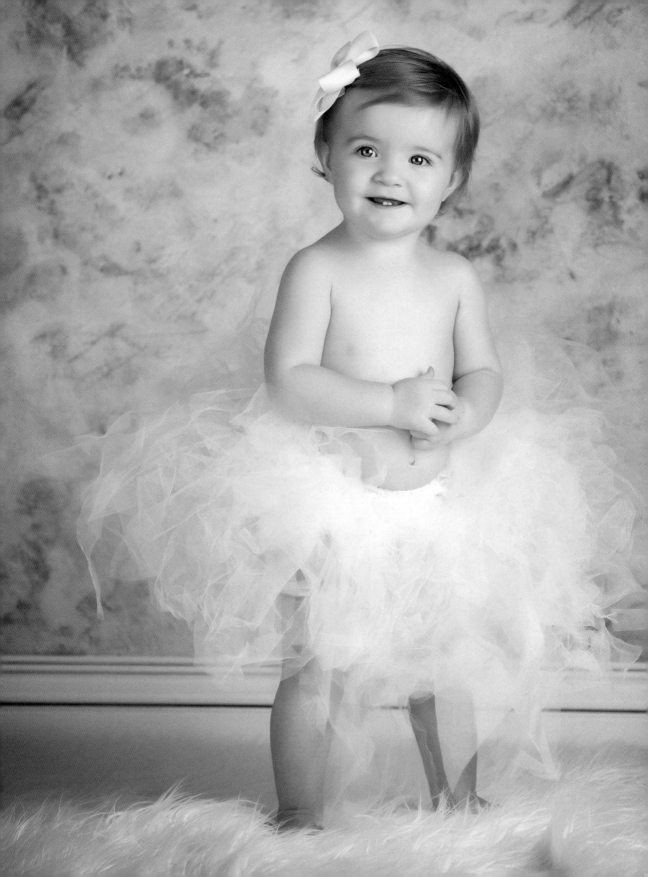

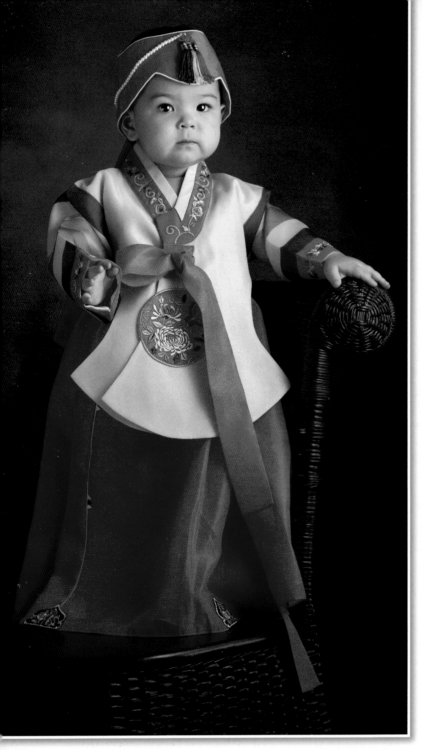

The only exception to that rule is if the parents bring in a particular outfit that has deep significance to them, such as an heirloom christening dress. Memento shots should be taken closer to the beginning of the session to ensure that you get plenty of good images while the baby is happy. In most cases, though, the baby arrives in a play outfit, and the parent brings one or two nice clean ones for the session. You should get the baby's socks off first thing so that little lines on their feet and legs go away. Then start with the most minimal look, such as a tutu and flower headband, and work your way up from there.

Most kids are pretty serious at first, and if that's the case, just go with it. Some pensive, shy shots while they are feeling more subdued are a great way to start the session. The energy level is sure to build from here, so don't rush it. Pose them sitting on the floor or a chair at first, and then move them into standing position. To encourage a child to stand near a chair and not wander around, drum your hands on it to get the baby engrossed in also doing that, and then go back to your camera. Once you get a few great shots of those poses, move on to the baby steps series. Instruct the parent to hold the baby near the background and let them walk toward you together. Hold a

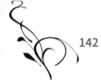

Sabrina

rubber chicken or ball directly over your camera to get the child's excitement going. You might need to do this several times to get enough for the storyboard, but it's worth the effort to produce this very popular product!

Another key product for this session is the birthday cake series. You should absolutely wait until the very end to do this one, and only if the client opts for it. This is a great feature for a first-birthday announcement, so be sure to show a sample or two to your clients during their pre-session consultation. They need to provide the cake—preferably a white cake (colored frosting takes forever to clean up!) with a colorful candle. If you are worried about the mess, lay a clear tarp or some cling wrap on the floor and then cover it with a nicer-looking piece of cloth to make for a much easier clean-up afterward—and I charge my parents a $25 clean-up fee. I prefer to photograph this series on a white laminate floor. You must be very quick with these shots, as some babies dive right into the cake. However, more often than not, getting them to interact with the cake takes some enticing from Mom or Dad.

Believe it or not, many babies are uncomfortable with making a huge mess and only tentatively poke at the cake or run their fingers through the frosting. It is not unusual for me to take some frosting and dab it on babies' faces or for me to "dig in" to the cake a little. Once babies see me doing that, they are often more comfortable decimating the remainder of the cake. One of my favorites was a little guy who got so into what I was doing that he actually picked up the entire cake plate and put his face in it! However, you must also be prepared for the child who does not appreciate your efforts and starts to cry. The birthday cake series should have a minimum of four images that cover baby looking at the pristine cake, that first tentative tasting, hands in the cake and some on the face, and then the final shot—the big mess! This is always a sure seller, because it is a beautiful keepsake of a special day!

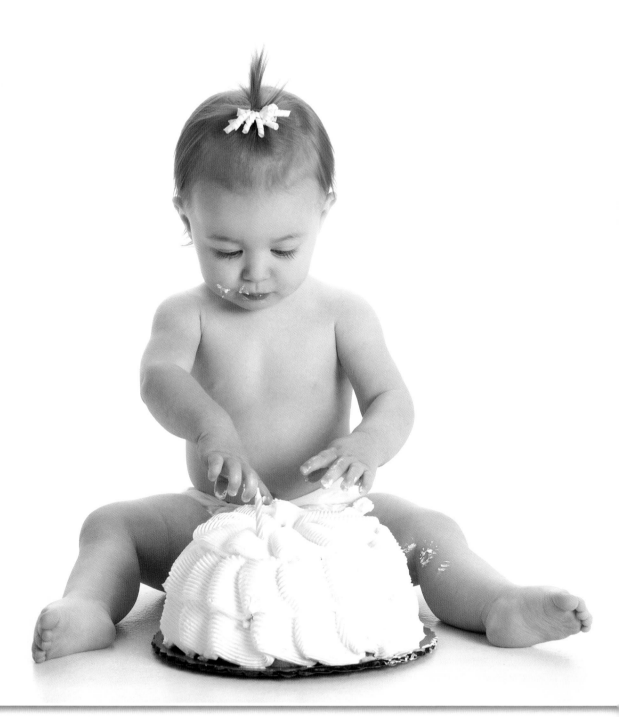

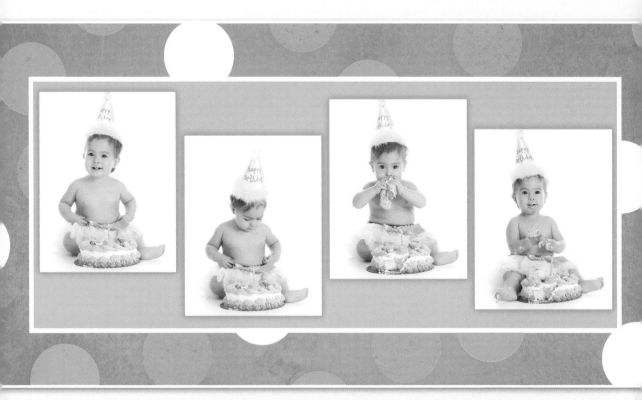

By the end of this session, you should have plenty of material to work with, as you will want to offer your client several products, including a baby album, first-birthday announcements, play-date cards, the baby steps and birthday cake storyboards, and any additional wall art and the framed art or folio that comes with their baby plan purchase. This is it! Make it count!

Keep in mind that once your client's baby turns one, you have worked with the family 10 to 20 times in the first year. After completing the consultations, the sessions, and the sales and deliveries of finished portraits, you are now the official family photographer. At the end of the first-year session, I present my clients with a special gift and educate them on my baby follow-up plan, a children's program that covers ages 18 months, two years, three years, four years, and the big fifth year. Just like the baby program, it is a set price and includes some bonus offers. Clients love programs and are more than willing to pay the fee to ensure that they keep those important years documented. When building your baby program, start thinking about the future, because babies grow fast and provide a wonderful opportunity to create clients for life.

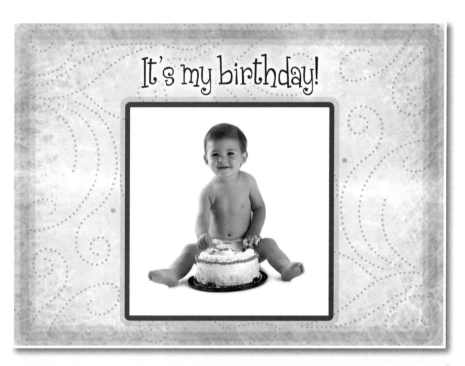

It's my birthday!

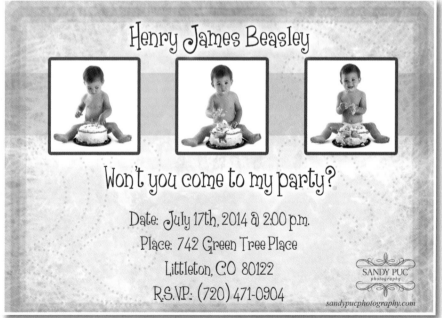

Henry James Beasley

Won't you come to my party?

Date: July 17th, 2014 @ 2:00 p.m.

Place: 742 Green Tree Place

Littleton, CO 80122

R.S.VP: (720) 471-0904

SANDY PUC
photography

sandypucphotography.com

Baby plan graduate gift

Chapter Thirteen

Success in Sales

Y ou can't be a successful photographer if you aren't also a successful salesperson. A lot of newcomers to the industry struggle with this part of the business, but sales are easy to analyze and, with practice, improve dramatically.

A successful sales meeting starts before the session even begins. Although I've covered the pre-session consultation already, I want to stress again that this is an essential component of a good client experience and healthy sales numbers. This 30-minute meeting allows you to show samples of your work, gather information, and, most importantly, establish an emotional connection. Try not to make this meeting about you—make it all about your clients. Whatever type of session the clients are going to have, emphasize that phase of life by showing images from similar sessions and telling stories about those clients and their experiences to help your new clients know that you understand the goal of the session and are going to deliver gorgeous results. Show your work as a means to create a relationship with the clients, not as the sole focus of the meeting.

Once the pre-session consultation is complete, your clients should think of you as a friend. You and the clients will have a good idea of what to expect from the upcoming session. Although this step might seem like an extra investment of time, it actually saves you and your clients a lot of time and energy at the session itself, because you all know the expectations and have much less need for clarification, allowing you to simply execute the session. The consultation also establishes a level of trust between you and the clients that improves the session results immensely.

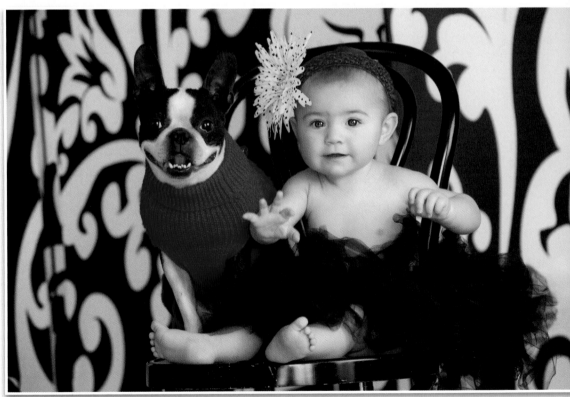

Immediately following the photography session, before the clients leave, you should schedule the sales meeting. I recommend allowing no more than a week to pass between the session and the sales meeting. At my studio, I allow three days to prepare for the sales meeting, so when I escort the clients to the reception area, the sales appointment is scheduled for four days from the session date. The purpose of this time frame is to keep the excitement level high and to get the ordering process started as soon as possible. This is especially true of sessions that occur in a rapid sequence of life events, such as maternity and first-year baby sessions. The longer it takes to place the order, the less excited and more distracted the clients will become. More sessions create more options, and order numbers typically decline when this happens. That is why it's very important to keep a brisk pace between each session and the sales meeting.

Capturing the Art of Life

Date: _____

Time: _____

303.730.8638
www.sandypucphotography.com

This time has been set aside at our studio exclusively for you. You will have the opportunity to view your portrait session and make your final selections. Please make sure that everyone involved in the decision making process is in attendance. We want you to be relaxed and enjoy yourself as you choose your favorite images. We look forward to showing you your images.

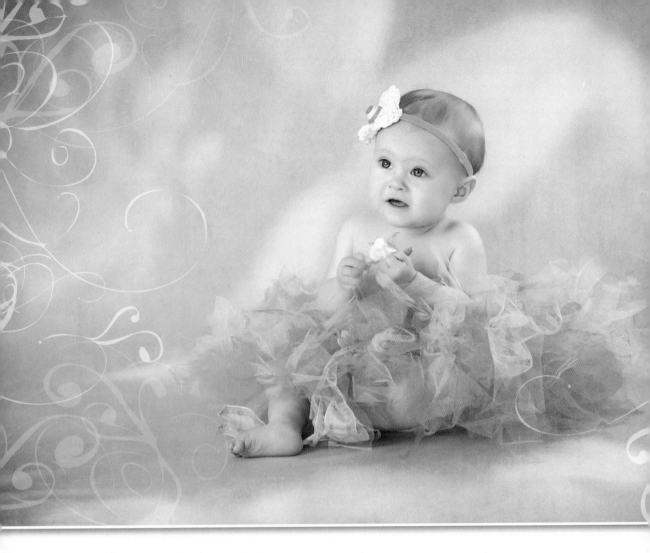

Send your clients home from the photo session with a reminder appointment card for the sales meeting. Two days before the appointment, send a reminder e-mail as well. Both should clarify that all decision makers need to be present for the sales meeting. This avoids subsequent sales meetings and postponed orders and payments. Typically, women are your target clients, because they are the driving force behind the booking and executing of the sessions. However, in many families, the husband may have the final say on large purchases and therefore absolutely needs to be present during the sales meeting. In these cases, you will find more often than not that when the father is not present, decisions can't be made, images are requested to be posted online for the clients' review (a BIG mistake), or a second appointment must be scheduled. That said, when the father does come to the sales appointment, typically there is no need to reschedule, and payment is collected then and there. A second sales meeting is totally avoidable and is more of a costly mistake than you might think. Even

a decent $800 order becomes much less profitable when you consider the time invested between a one-hour photo session and one sales meeting versus a one-hour photo session and two or more sales meetings. Your profit is very nearly split in half, and you've lost income that you could have earned in a new sales meeting or photo session. That is why it's important to close the sale in one sales meeting, every time.

Once your decision makers have arrived, it's important to really deliver during the sales meeting. I've learned over the years that there are good ways to do things and better ways to do things. The better you execute your sales meeting, the better your sales will be. It starts with a comfortable environment. In my studio, I have two sales rooms, a frame room, and a waiting room separate from the lobby area. The frame and waiting rooms are both full of product samples and framed wall art, presented in a homey décor that helps clients envision their own portraits in those products displayed in their own homes. I have beverages and snacks available for clients to enjoy while they take in their surroundings for a few minutes before they are shown to a sales room. Each sales room is laid out in a particular way: A standard size sofa is against a back wall, with an appropriately sized framed portrait hanging over it. At the beginning of the sales meeting, a projection screen mounted above the sofa comes down, so clients can visualize their images over a sofa. Two comfortable arm chairs are positioned across from the sofa, facing the projection screen. These chairs are spaced far enough apart that couples can take in the slideshow individually yet still be close enough that they can share the moment.

A sales desk is positioned near the back of the room, directly behind the clients. I keep this desk uncluttered and clean, with a computer that can access the files and control the slideshow. One of the advantages of sitting behind the customer is that you can often pick up on the nonverbal cues, both positive and negative, taking place without appearing too obvious. Having that advantage can help you determine which direction to take your meeting in to achieve the optimum sale. You can also be invisible as clients debate and discuss what they would like to purchase.

This layout should be as homey and stylish as possible. If you aren't a natural at designing your space, seek out the help of a friend or interior decorator who can make the most of this area, be it a room in your home or several thousand square feet. Keep an inviting, orderly, and clean space at all times. Air fresheners or candles with a light pleasing scent are a must, and freshly baked cookies are a wonderful snack that can fill a space with delicious aroma as well. There's a reason that real-estate agents bake cookies or bread before they show a home—the scent works like a charm.

Once you have laid out your space and created a welcoming ambiance, the sales experience begins with a slideshow that includes 30 to 40 of the best images from the session. You can decide whether you want to display all your images with quick action work, but it is imperative that at least three to six of the best images have full artwork, such as blemish removal, skin softening, or eye enhancement, done. Don't include every image you took—going through and editing out the bulk of them is your job, not the clients'. As any photographer knows, this is a tough job, as it can be hard to part with

images, especially at first. By now, I am very quick about editing down my images. It's not that I don't care about them, but there is an art to it, and I've gotten very good at knowing what I'm looking for and letting go of the rest. If you force your clients to do this for you by including too many images in the slideshow, you'll have much less time available to actually sell. Keep in mind, the average sale includes only five poses—five! Too many options are overwhelming and can negatively affect your numbers, so showing 100 images means that your time is spent narrowing them down instead of showing products to the clients and increasing your sale.

The structure of the slideshow is critical. The presentation should include a custom introduction slide with the subject's name and should be accompanied by music that emotionally reflects the images shown. Be sure to mark about six to ten images with the caption "Artist's Favorite." By personally selecting and marking your favorites, nearly 100 percent of the time, you will sell these images. You can use a variety of software products to create a slideshow; I have found ProSelect (www.timeexposure.com) to be an excellent way to present my images.

Title and end slides

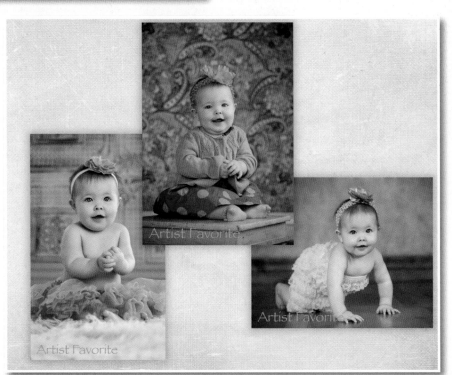

Artist's favorites

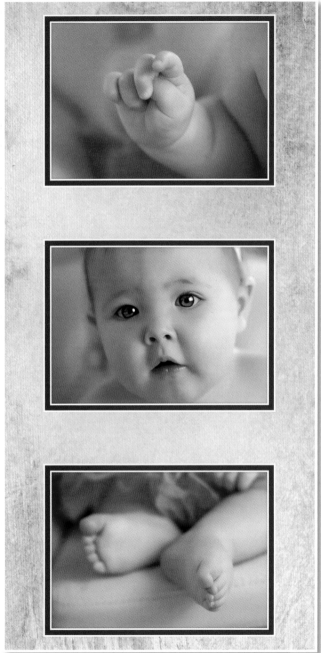

Triptych collage

When the slideshow begins, the lights should go down, and the music should start. This is a time-tested technique—it always creates a powerful emotional experience that puts your clients in the right state of mind to invest in their portrait art.

I am a big proponent of projection. I was hesitant to leave behind 4×5 proofs and incorporate it when I did. I was afraid my clients would revolt and leave my studio, but my mentor of many years encouraged me to try it when I came to her in tears one day. I was upset that I was missing out on my own family's memories because I was working too much. She promised me that if I switched to projection, I would double my sales. The first day I tried it with a session I had been less than thrilled about. It was a family whom I had been photographing for several years, and they were having a family/maternity session with their three-year-old boy, who was autistic. He was restless and distracted throughout the session, and I wasn't sure how amazing the results would be. But when the lights dimmed and I showed my first slideshow on projection, I looked at my clients to see that both were so touched by the

presentation that they were moved to tears! The images weren't perfect, but displayed in that way to those clients, they were absolutely perfect and filled with meaning. That day, I finally understood the bigger picture and have been using projection ever since. I can genuinely assure you that it will dramatically improve your sales numbers if you apply it to your business, no matter which type of space you are working with. Typically people who switch to projections double and triple their sales. In my first year of sales after going to projection, I tripled my income and reduced my session count. I swear by this "work smarter, not harder" approach even today.

Once the slideshow is over, it's time to start comparing images, narrowing down poses, and offering your clients packages and products that suit their session types and themes. I've explained previously why I like to use a credit system—it just works. Beyond that, a bonus incentive program is a great way to close the sale. You should tell clients that they must complete their order that day to be eligible to receive the bonus. As the sale increases, so should the value of the bonus item. For larger orders, offer one nicer bonus item instead of several lower-value ones. I used to offer several items for large sales and found that doing so actually did more harm than good. Clients would become frustrated by having to select more products when they had already completed their orders, and there were times when multiple bonus items were used to replace actual products that had been ordered but were now removed from the shopping cart.

157

Gifts and Bonuses

Level One Bonus
With $650 purchase: Receive a one-level wall frame upgrade and 5% off your holiday cards or birth announcements.

Level Two Bonus
With $950 purchase: Receive the above, or a two-image necklace or a one-image crystal bead bracelet, plus 10% off your holiday cards or birth announcements.

Level Three Bonus
With $1350 purchase: Receive one of the above or a three-view folio or four-image keychain, plus receive 15% off your holiday cards or birth announcements.

three-view folio

Eclectic

Level Four Bonus
With $1800 purchase: Receive one of the above or a small cosmetic bag or an Eclectic art print and 25% off holiday cards.

All gifts and bonuses are available if order is placed within 30 days of session at first image presentation. As always, *Sandy Puc' Photography* stands behind our 100% satisfaction guarantee.

Bonus items, structured correctly, help you close the sale, and custom products give your clients plenty of options to choose from to create the sales numbers needed to get the bonus item. Wall art is always the main product that clients are looking for, as well as some smaller gift portraits. Several professional labs are out there. Do your homework to find the one that works best for you and offers the qualities that best suit your studio, whether it is location, fast turnaround times, or a variety of specialty products. My studio uses Bay Photo (www.bayphoto.com) as its portrait lab of choice. This midsize company offers amazing quality and personal customer service that I have depended on for many years now. It also offers unique products, such as:

◈ Metal prints

◈ Gallery wraps

◈ Wave books

◈ Three-view folios

◈ Wall displays

This is just a sample of the products I offer, but it's a great start to building a product line that your clients can choose from. It can be tempting to offer your clients every product available, but doing

so can be expensive, because you need to order a sample of each product that you want to offer—and, again, too many options is not always good. Start with one or two items for each niche that you serve—a few for families, children, babies, seniors, and so forth. If you only serve one niche, then you can get a little more elaborate with your sample products right from the start, but you certainly don't need to. Over time, you will slowly begin to add to these lines and remove items that don't sell, keeping only the ones that your clients respond well to.

You should offer an album for each niche as well. Templates are a good route for these, as they are easy to use and look amazing. I use templates from my site, Ukandu.com, and I use Finao (www. finaoonline.com) and Bay Photo for my studio's albums. For a maternity and baby client, the two most popular albums are one that includes maternity and newborn portraits and one that captures the entire first year.

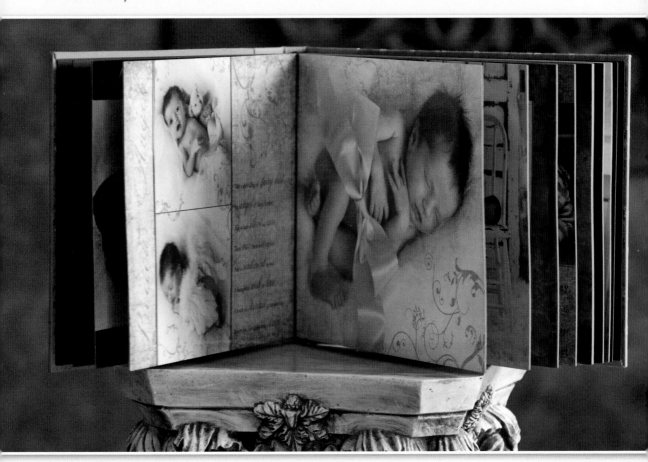

Beyond these products, portrait handbags, jewelry, announcements, brag books, and holiday cards are at the top of my studio's list of best-sellers. These types of products make wonderful incentive items and can often double as a marketing tool when updated with your studio logo. Announcements, holiday cards, play-date cards, calendars, and other products of that nature should always feature your studio logo and contact information. Not only are these products that clients love, but they allow the clients to basically do your marketing for you, as long as your information is available on the piece.

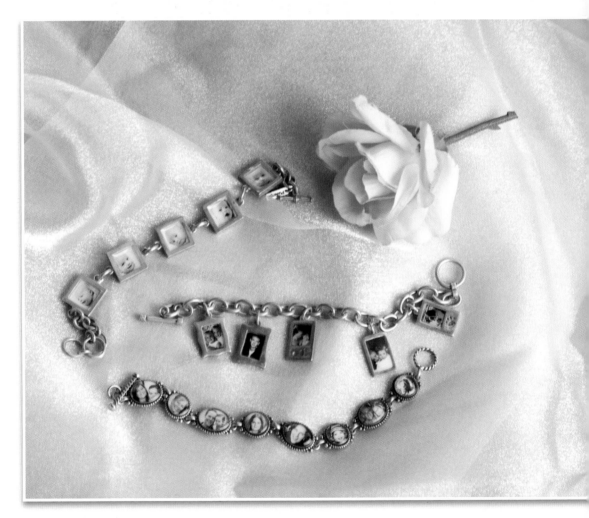

Portrait jewelry

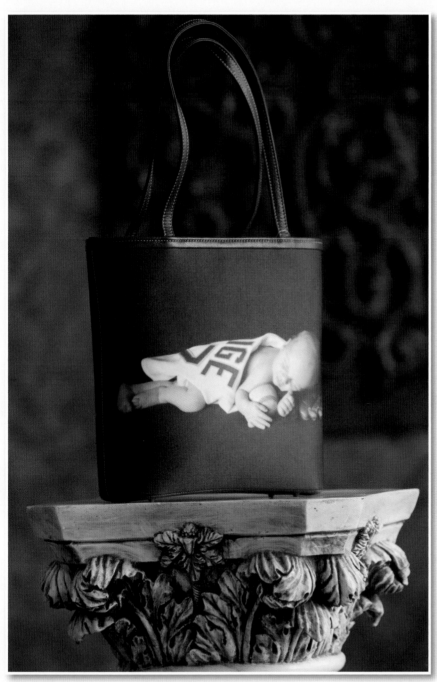

Portrait handbag

Selling Your Files

Nowadays, the number-one item that clients ask for is the digital file. Back in the film days, it was almost unheard of for clients to request the negatives, but in the age of instant everything, many clients expect the files and threaten to go elsewhere if they are not available. This is a hot-button issue in the industry right now, as some photographers are simply selling all their images on a disk for $99 or something outrageous like that. I can't compete with that price point at all, nor do I want to—and neither should you. Don't devalue your work by literally giving it away in digital files. I have mentioned several times that the majority of my clients come to me as referrals because they saw my work hanging in their friend's home, sitting on the credenza at work, or even on their iPhone cover. In my many years in the business, I have *never* had anyone approach me and say, "I came to you because so-and-so showed me a disk of your images."

Take a look at your pricing structure and determine your minimum sale number (that is, the amount you must sell to make a profit). A single digital file should be that price—whether it's $400 or $4,000 doesn't matter. Most clients hear the number and move along to prints and other products. I don't believe in telling clients "no," but I do say "however" (which is "but" with a tuxedo on). When someone wants to buy a digital file, I say, "Yes, I do sell digital files. However, they cost $XXX." This response allows me to offer this option to clients without encouraging them to go that route. Regardless of whether you choose to offer them, the issue of digital files should be addressed during the pre-session consultation. Finding out in the sales room that your clients only want some images on disk can effectively end that sale and the relationship.

That said, digital files can make a great incentive item. Two or three tiers of sales goals should include one, two, or three digital files of the images ordered as a reward. For years, my preference was to put these files on a custom-printed disk with my logo and studio name, which was delivered in a custom-printed case with my logo and the clients' image. Today, I am exploring alternate delivery methods, such as USB drives and even e-mail. One fact that never changes is that the more elaborate the packaging, the more value you are attaching to the file, and the more your clients will respect it.

Each digital file you sell should be accompanied by a legal image-use notice, which is a copyright protection document that should be drawn up by a lawyer. The notice should state that you still own the copyright to the image(s) but that the clients may use them for personal, noncommercial purposes only. This document should be signed by you, with one copy going with the clients and one copy remaining in their file for your own records. Chances are, people will still abuse the copyright, regardless of whether you know about it, and it probably won't be worth the time or trouble to pursue the matter if they do. But the document does protect you should the need arise, and it often deters most clients from using your images in commercial settings. Be as specific as possible in this document, citing the differences between personal use and commercial use.

That pretty much covers the digital file conversation, and I think it's an important one to have. But remember that unique, custom products are one thing you can give your clients that they will have a hard time getting elsewhere, so try to focus on them more than the option of digital files. If digital files are that important to your clients, stay focused on offering them as a bonus incentive and help your clients guide the order toward the necessary sales level.

If clients try to barter with you, be clear and concise on this point: Your prices are carefully set to cover your costs and cannot be negotiated lower. If people don't respect your work, they don't have to buy it and that doesn't mean you owe it to them to give it away. Some people may try to bully you into lowering the price, but don't fall for it. Maintain good eye contact and be friendly and confident. If you don't back down, they will probably come around. If not, sadly, it's their loss, but (as discussed earlier) you did collect your session fee, so you've been compensated for your time either way.

When the order is placed, collect at least a partial payment if not a full one at the end of the sales meeting. Let your clients know the timeline of when their order will be ready and assure them that you will contact them at that time. I have found that it's better to quote a later date for pickup than what I actually estimate it will take. I tell my clients that their order will be ready in six to eight weeks and write a date that is eight weeks out on the sales invoice. I would rather they be delighted because their order arrived early than to have them be upset because there was an issue getting a frame or something and now their order is late.

At the end of the sale, escort your clients to the door and thank them for their order. Every step of the way, they should feel welcome and the focus of all your attention. Remain professional, yet approachable and receptive. With these sales techniques, you will see your numbers growing in no time.

Chapter Fourteen

Workflow and Production

I have always said that photography is a complete process that begins at the moment clients enter my door and ends the moment they leave with their order. Photography is not just the act of taking photographs. Workflow and post-production are two essential areas where many photographers find themselves held up with the details. As you probably know, these topics can fill multiple volumes in their own right. Workflow consists of editing, retouching, ordering your portraits from the lab, and preparing images for delivery. This encompasses a wide range of tasks, some of which I only touch on briefly here. What you really need to know can be found within a few different software tools, each of which can be studied in great depth. You will be amazed at what these can do for you from the fundamentals to far beyond.

The editing process includes selecting the very best images the session has to offer and may also include basic adjustments and retouching for the sales presentation to your clients. Although a lot of great software is available, I use Adobe Lightroom in my studio for this step.

Photoshop is an excellent option for retouching images. Lightroom is a workhorse, but for harder, more complex work, such as head swaps, Adobe Photoshop is the way to go. Keep in mind that these software programs are constantly updated and you will need to research the options in the latest versions. The good news is they tend to get easier and faster to use with each release.

For the sales process, as I have mentioned before, I consider ProSelect to be the best software out there to create dynamic presentations. ProSelect was created for photographers and is the most comprehensive software available. Take the time to check out the site and learn about all the options as you watch the tutorials. This is an incredible tool, but it does have a learning curve. However, the time you spend learning will translate into much higher sales.

Depending on how the photography session is going, I may put my camera into video mode and capture several minutes of live-action video, which I then incorporate into the slideshow presentation to offer more emotional impact. Because ProSelect does not support video, I use Animoto to create the initial slideshow presented at the start of the sales appointment, and then the salesperson reverts back to ProSelect for the actual order placement.

The framing selection at your studio can be anywhere from nonexistent to extensive. I use GW Moulding and the Levin Company for my frames, and they have provided me with corners of frames from every thickness along with mat samples that I can show my clients. Although I have an entire frame wall, I

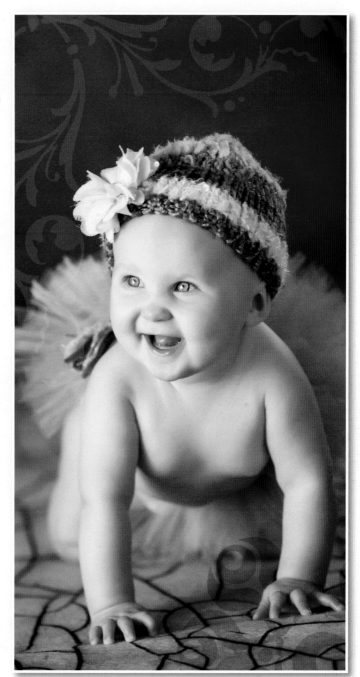

think that even 10 to 20 corners and matting options will serve you well. A metal wall and magnets are a great way to display corners and art products, as are the traditional Velcro backings against a carpeted wall. You don't need to devote an entire room to frames—just maintain a clean and organized space in which to display options for your clients.

What happens if you don't have physical room to display frame corners? ProSelect includes virtual GW Moulding and Levin Company frame corners in the program, so I am able to upload the frames and drop them around the images in my slideshows. If you don't use ProSelect, some companies, such as Levin, offer software that allows you to upload the clients' image and insert it into different frames on your computer screen so your clients can see how the combinations will look.

When you show framed pieces to your clients, it's most important that you be confident. Tell them that you have handpicked these frame styles to best match your style of photography. That is more important than offering a wide selection. And as the saying goes, you sell what you show. So wherever you display frames, create a product wall where you can showcase art products, such as collages, canvas gallery wraps, and so on. The most persuasive argument that I offer is the ability for clients to take that beautiful piece straight home from the studio to hang on their wall. I also don't hesitate to mention horror stories of a large portrait being put into closet for framing later, only to have a golf club go through it, or the one placed "safely" in the bedroom that the cat thought made a lovely $1,500 scratching post.

Don't have the time, room, or desire to frame your own products? A few companies offer a service where you can submit the digital file along with the clients' frame/mat choices, and they will print and frame the product and ship the completed piece back to your studio for delivery. This is a great option if you are working out of your home or a very small space that does not have room for frame storage.

Don't underestimate the impact of the presentation. When I was a younger photographer, I was pretty casual about how I delivered my prints. Over time, I noticed that higher-end studios use elegant, branded packaging for even the tiniest orders. Every detail of your presentation should be professional and sophisticated. Don't sell yourself and your work short by delivering your work in anything less than the best. Boxes, bags, and folders should be custom ordered to feature your studio logo. Tissue paper in a color that matches your branding is also an attractive touch that protects unframed images. Do whatever you can to give your clients a lasting impression of quality when they receive their order.

Last but not least, make sure each and every print bears your studio name or logo. Gift prints are typically not mounted and have a digital signature on them, but I hand-sign any mounted portrait that is 11×14 and larger with a Sakura Extra Fine Point pen. For black and white images, I use silver ink, and for color images, I use gold ink. This added detail makes each print a piece of art.

Also, I provide a Certificate of Authenticity with any mounted portrait. This documents the size of the portrait, the image number, the date of creation, and the replacement cost of the portrait only (not the frame) for insurance purposes. I recommend that clients keep their Certificates of Authenticity with their important papers in case of fire or other disaster.

Certificate of Authenticity

Portrait of _____ Image No. _____

Made in the year _____ Value for insurance purposes_____

Authentication and Copyright by Sandy Puc' Photography

It is unlawful to copy, reproduce or alter photographic portrait

7201 S. Broadway, Littleton CO 80122
303-730-8638 | sandypucphotography.com

Your Portrait Registration

SANDY PUC'
Photography

Thank you for choosing Sandy Puc'
Photography to create your art piece.

This registration certificate states the authenticity of
your portrait for insurance and appraisal purposes.

We suggest that you keep this certificate as a record
of both your original purchase and of its copyright.

At this point, your clients are thrilled to have their beautiful portraits ready to show to the world and are ready to sing your praises. Your goal is to make it very easy for them to do that, so make sure the bag they take home includes those referral wallets we discussed earlier, plus any information on relevant, upcoming promotions in your studio.

When your clients pick up their final order, this is your opportunity to wow them one last time. If you have done your work right, they not only will return but will refer their friends as well. The extra efforts you make at each step of the photography process will pay off in the end.

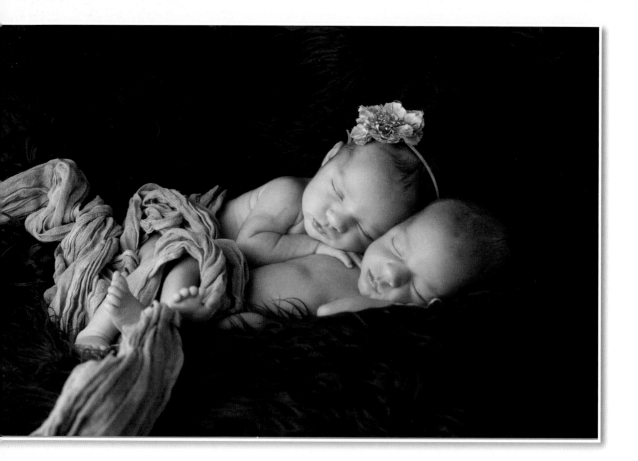

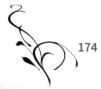

Chapter Fifteen

Giving Back

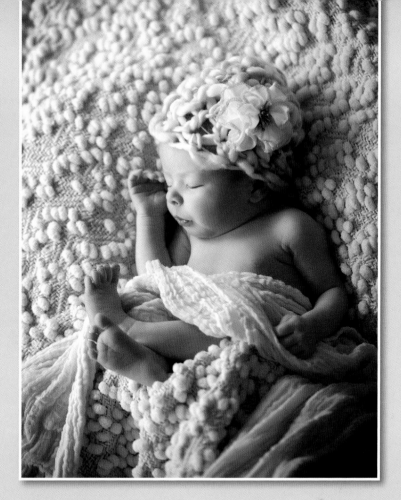

"We make a living by what we get,
but we make a life by what we give."

—Sir Winston Churchill

Winston Churchill's famous quotation has guided my business and personal philosophies for many years now. In each and every situation where I try to give back, I have always found that I get more than I give. They say the difference is tenfold, and I really believe that is true. I've had the honor of working with many major charities throughout the course of my career, which has enriched my life in so many ways. I love giving back to local, national, and global charities, and I think it's important for everyone to seek out a cause that really speaks to them.

I found my cause several years ago, when I co-founded an organization called Now I Lay Me Down to Sleep. It happened one February day in 2005. I was in the middle of a session. I am rarely interrupted, but my receptionist stepped in and asked me whether I would be willing to photograph a baby in the hospital who wasn't doing very well. I had some plans that day and didn't want to cancel the session I was doing, so I said yes, I could do it the next day. My receptionist then explained that the baby probably wouldn't make it through the night. As you can imagine, my heart broke when I heard this, and I agreed to cancel my plans for the rest of the day. A few of my staff joined me as we prepared for the session and made our way to the hospital. It was a tragic day for the Haggard family, and because they had seen my studio's art displays throughout the hospital, I had been requested to help document the last moments of their son Maddux's life. Nothing could have prepared me for that experience, but it was the catalyst that started a worldwide movement that has changed many lives today. Sometimes you just have to go—even if you are scared, even if you are heartbroken. Life offers moments when there is only one right thing to do. This was one such moment for me.

When we got to the hospital, we learned more about Maddux's condition. He was ten days old and had a rare condition that required him to be on life support. Cheryl, his mother, was so upset that she could not even speak. Mike, his father, was a little more collected, and deeply appreciative that we had come. They knew that their fourth child and second son would pass away once he was removed from life support. It was incredibly difficult to photograph this moment for them, but it was what they wanted us to do.

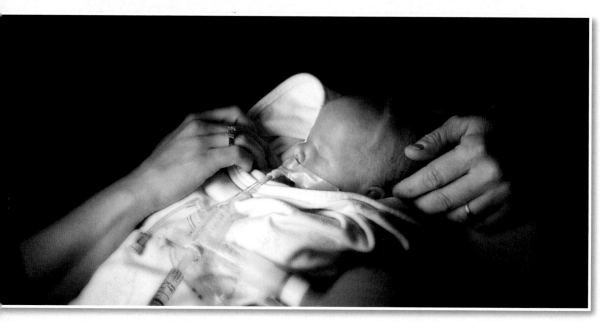

I started the session with little Maddux still hooked up to life support. Once he had passed, I would photograph him detached from all medical paraphernalia.

Tubes and wires covered his body, keeping him alive as I photographed every detail—his tiny hands, feet and face. I kept trying to capture one more thing, one more moment. I didn't want to miss a single feature. But finally, I knew there was nothing more I could photograph. It was time for the family to be alone together while Maddux was taken off life support.

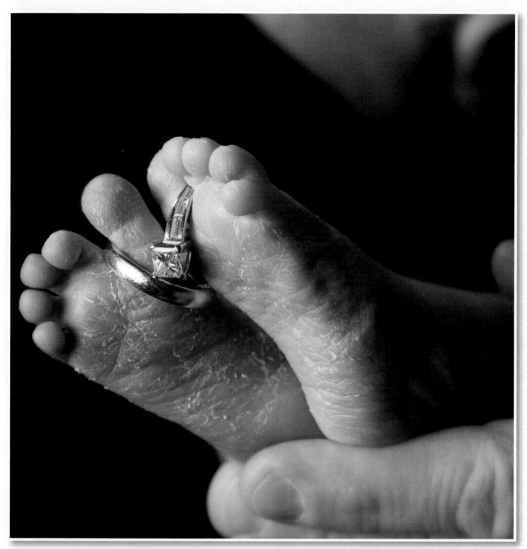

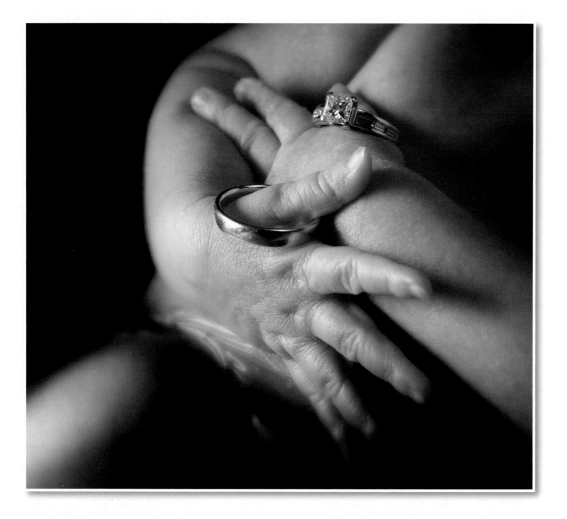

My staff and I waited outside the room for about forty-five minutes, and we didn't speak a word. It was heart-wrenching for me and my assistants. The nurses, whom I had always thought had a dream job, were equally devastated. After what felt like ages, a nurse with a tear-stained face emerged from the private room. We knew then that Maddux had passed away. It was so difficult to do the second session, but it seemed as though the roles had reversed for the Haggards: Cheryl had a sense of peace and calmness, while Mike was beside himself with grief. With the tubes removed, the images from this second session were quite profound. My assistants and I worked in silence, photographing Maddux one last time, alone and being held by his parents for the first time free of wires. I did an entire session, with the full set of standard newborn poses. It was one of the most emotionally exhausting experiences I have ever had.

180

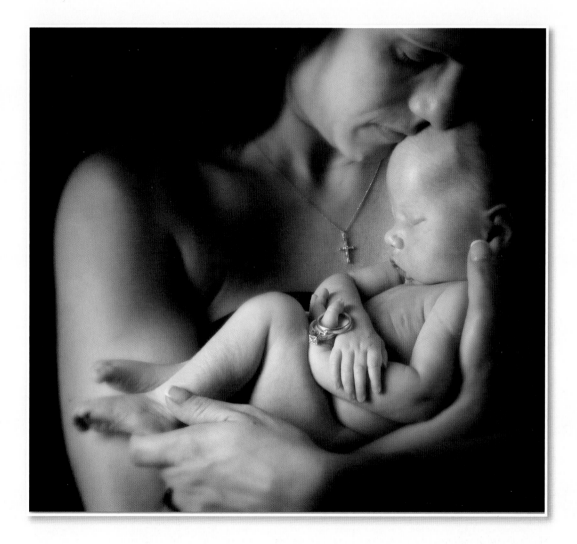

When I got home that night, quite late, I went to each of my four children's rooms and spent time watching them dream, feeling an overwhelming sense of gratitude for each of them. At some point, I fell asleep in my youngest daughter's bed. The next day I couldn't bring myself to go in to work. As a business owner, this rarely happens, but I just couldn't go. I rescheduled all my sessions and stayed home, trying to process the events of the previous day. Around 9 a.m., Cheryl called me to thank me for doing the sessions and asked when the images would be ready. I was surprised by her call but assured her that I would get them ready as soon as possible.

When I viewed the images, I was amazed at how striking the second session was. Without all the tubes and wires, the portraits were beautiful. It brought back the day, but not in the way I was expecting them to. Wanting everything to be perfect, I asked a good friend, Dave Junion, to help me with the artwork for the portraits and to create a slideshow for the Haggards. He graciously helped me through that process, and during that time, I received a phone call from Cheryl almost every day to find out whether the images were ready.

Their appointment date arrived, and I instructed my sales team to let them watch the slideshow in privacy for as long as they needed to and to let them order whatever they wanted at no charge. I felt it was the very least I could do for this family who had gone through such a terrible loss.

I waited outside the door and could hear the slideshow end and then restart. After a few minutes I left, knowing they would need time to process everything. They ended up watching it for about an hour, over and over again. When they finally emerged from the sales room, Cheryl asked me, "Do you know what you've done for me?"

"What?" I asked her, tentatively.

After a short pause, she gathered her emotions and said to me, "You've given me my son."

It was a transformational moment for us both, as we realized the true value of those portraits. From there, Cheryl and I became bonded in grief and hope. Over time, we realized that every day hundreds of babies die. These babies usually go undocumented, and the parents are left only dreaming of the children they loved so dearly. From those early conversations, we determined that we needed to help. Through tireless work, Cheryl and I founded Now I Lay Me Down to Sleep (www.NILMDTS.org), which has grown into a worldwide nonprofit organization that serves more than 40 countries and includes more than 14,000 volunteer photographers. Because NILMDTS spans the globe, it became necessary to have the organization become a certified nonprofit and be managed by a paid, knowledgeable staff. Over time, I have been able to relinquish many of the day-to-day operations to this amazing staff and refocus my energies on my own studio. I still photograph the sessions when I can, and every time is still very difficult for me. I also sit on the organization's board of directors to help guide the vision for the future. We will not rest until every parent in the world who will lose a child has the opportunity to have a precious image to remember his or her baby.

I know it's just as difficult for every photographer who donates his or her time and talents for NILMDTS. The more people who contribute, the less of an emotional burden the volunteers carry. Some cities only have one participating photographer, which is often a problem. But the organization is growing every day, and the healing and comfort that the portraits provide, all of which are free of charge, are truly priceless.

This is my main cause. NILMDTS is very close to my heart, and I know it is part of what my life's work was meant to be. It's difficult work, but it means a lot to me. If you are interested in volunteering, I encourage you to visit the website at NILMDTS.org to learn more about donating or volunteering.

Regardless of the cause you choose to work for, I know you will be blessed, not only through the experience of getting involved but also by seeing plenty of tangible benefits in your business. When you put a piece of your soul into a cause like that, you are sure to grow in amazing ways. There are plenty of ways to raise awareness and funds for the cause that speaks to your heart. Fund-raising events and sessions are a great place to start.

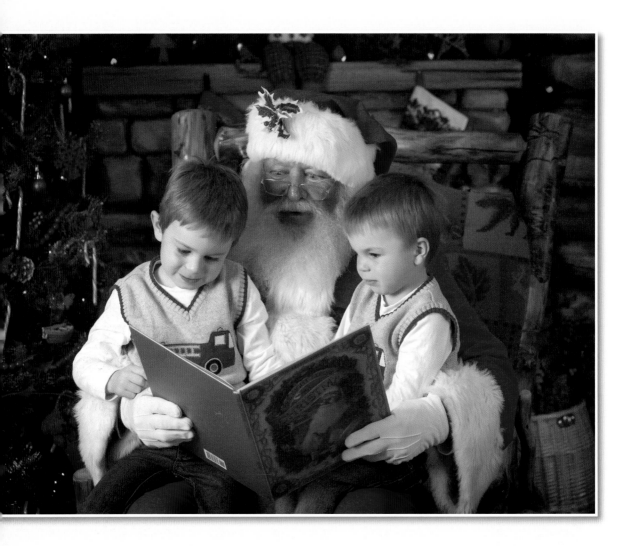

Every year, my studio hosts several fund-raising events, ranging from our Halloween Charity Event for our local food bank, to our Santa Charity sessions that benefit our Children's Hospital, to our Locks of Love hair drive. There are plenty of ways to give back, and events like these provide your clients and friends the opportunity to get involved too. School fund-raisers are another great way to help your community. If you want to start small, you can simply join a committee at a nonprofit in your area or volunteer some of your time. I also had the privilege of being the official photographer for the Susan G. Komen Race for the Cure event in Denver for several years. Seeing these huge groups of people, united by a desire to make an impact, get out and raise awareness and funds was absolutely phenomenal. It has changed who I am as a person forever.

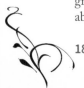

"When I stand before God at the end of my
life, I would hope that I would not have
a single bit of talent left and could say,
'I used everything you gave me.'"

—*Erma Bombeck*

Chapter Sixteen

Closing Thoughts

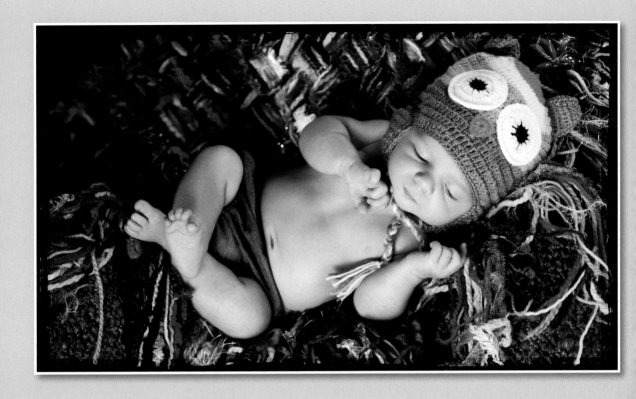

Throughout this book, I have shown why I believe that a baby plan is such an essential element of any portrait photographer's business. You now know how to add a thriving newborn and baby photography element to your offerings or how to enhance the one you already have. Every step of the way—from organizing your business and selecting the right branding, to capturing those maternity and milestone sessions in the first year, to post-production work and final delivery—I hope you remember what I have said about photography being a process. On a slightly larger scale, the relationships that you create with clients are also a process.

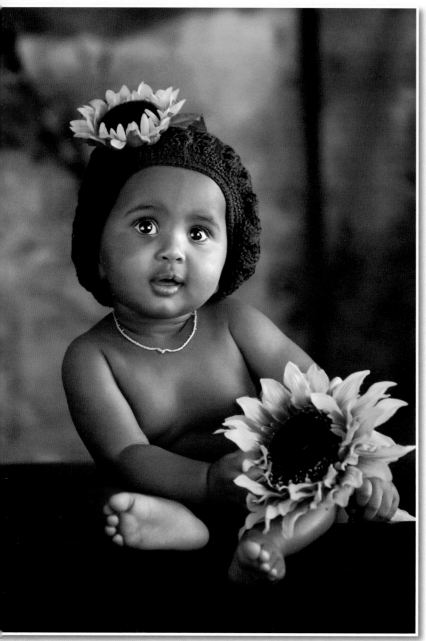

It's not over after their first session with you or when they pick up their order. It's not over when they complete their one-year baby plan and pick up that final order either. With the right care and attention, these clients will return to you time and time again for the rest of their lives. You will become their family photographer and have the joy and privilege of documenting each milestone in their journey. When you look at the client relationship in this way, as a process, you can build your business on a firm foundation of love and appreciation that true success is made of.

I hope that you can create this dynamic in all your client relationships and have a bustling portrait business where every day you don't just have a session but a chance to catch up with a friend too. The best part? This type of philosophy will also lead you to more business, a higher income, and more of those perfect days that you've been dreaming of. If you walk away from this book with just one thought, I hope it's the realization of what that perfect day looks like for you and that you are one step closer to living it.

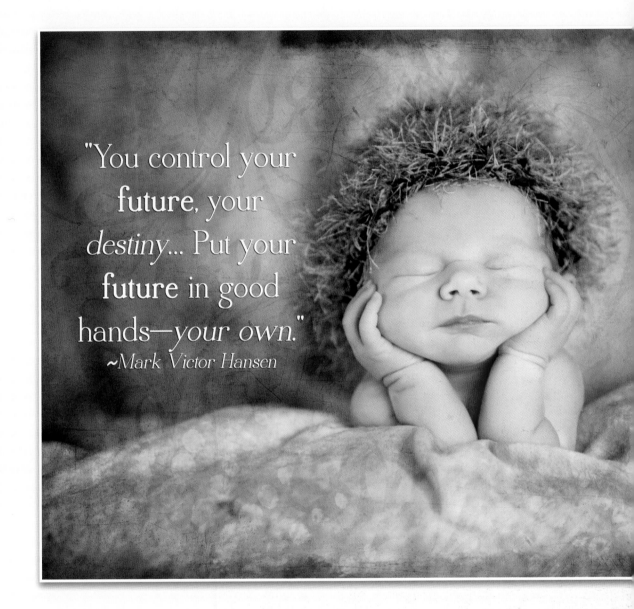

"You control your future, your destiny... Put your future in good hands—your own."
~Mark Victor Hansen

Index

Flexible, fast, and fun, DigitalClassroom.com lets you choose when, where, and how to learn new skills. This subscription-based online learning environment is accessible anytime from your desktop, laptop, tablet, or smartphone. It's easy, efficient learning — on *your* schedule.

- Learn web design and development, Office applications, and new technologies from more than 2,500 video tutorials, e-books, and lesson files
- Master software from Adobe, Apple, and Microsoft
- Interact with other students in forums and groups led by industry pros

Learn more! Sample DigitalClassroom.com for free, now!

We're social. Connect with us!

acebook.com/digitalclassroom
@digitalclassrm